GILLETTE CASTLE

GILLETTE CASTLE

A HISTORY

ERIK OFGANG

THE
History
PRESS

Published by The History Press
Charleston, SC
www.historypress.net

Front cover: Courtesy of Joe Mabel.

First published 2017

Manufactured in the United States

ISBN 978-1-5402-1626-7

Library of Congress Control Number: 2017931796

To the actor, the writer and the detective

A great actor is his character.
—William Gillette, 1914

Contents

Contents

Acknowledgements

This book came about after I wrote a series of stories on Connecticut castles for *Connecticut Magazine* in 2014. This series was launched thanks to the enthusiastic support of my editors at that time, Ray Bendici and Douglas Clement. Both Ray and Doug were integral in helping me find more Connecticut castles to write about and in encouraging me to leave the office in search of the spires and towers of the Nutmeg State. This series caught the attention of the team at The History Press, who asked if I would be interested in writing a book about Gillette Castle. This was a wonderful coincidence as I had already been mulling over the idea of doing something more on the "King of Connecticut castles." I felt it was so much more than just a building and provided a very real link with a man who had helped create our modern image of Sherlock Holmes. When The History Press and I agreed to go forward with this book, I began two years of research that would lead me through dusty archives and old building sites and ultimately reward me by increasing my understanding of one of history's greatest actors.

As I followed the surprisingly sparse clues about William Gillette's life, I was indebted to a number of people who pointed my research efforts in the right direction. The assistance of Alan Levere, a historian with Connecticut's parks system, was invaluable. He provided me with digital copies of hundreds of archived newspaper clippings concerning Gillette, as well as many of the images found in this book. Janice Nowik, president of Friends of Gillette Castle, was gracious with her time and knowledge,

and her support for the project was integral. The afternoon I spent with Harold and Theodora Niver, aka Mr. and Mrs. Gillette, was among the most rewarding of my many visits to the castle, and both of them were generous in sharing their story and their ample knowledge of all things Gillette. The staffs of the Mark Twain House and Museum and the Harriet Beecher Stowe Center were also extremely helpful when I visited both institutions early on in my research.

I quickly found that when it comes to the history of William Gillette's life all roads lead to and emanate from one seminal work on the actor's life: *William Gillette, America's Sherlock Holmes* by Henry Zecher. Exhaustively researched and painstakingly detailed, this seven-hundred-plus-page biography was my beginning guide to the actor and one that I found consistently helpful. Zecher's book remains the final word on the life of William Gillette and the number-one resource for those seeking to learn more about him, and I am indebted to the work.

Thanks must also be given to the staff I worked with at The History Press, particularly Chad Rhoad, who oversaw the final stages of the project.

Additionally, I must thank my parents for always encouraging my writing and taking me on a day trip to Gillette Castle as a child that led to a lifelong fascination with the place, as well as my wife, Corinne, who accompanied me on most of my visits to the castle and sacrificed many a weekend helping me search through old newspaper clippings.

Finally, thanks to the staff at Gillette Castle for passionately preserving such a singular spot and so many great stories and pieces of history. I hope this work will help in answering the many questions of curious guests who fall under the castle's spell.

Introduction

S herlock Holmes was dead.

There was no mystery as to the cause of death; it was murder. The great "consulting detective" had been killed in the 1890s, allegedly at the hands of Professor James Moriarty, criminal mastermind of London and Holmes's only intellectual equal.

But one did not need Holmes's deductive abilities to discern there was more to the case than met the eye. Moriarty, it soon became clear, was only a stand-in for the true culprit, one Arthur Conan Doyle, an Edinburgh-trained physician and writer of Scottish descent. Inspired in part by Joseph Bell (a surgeon at the Royal Infirmary of Edinburgh, whom Doyle had worked with and who was known for drawing accurate conclusions from small observations), Doyle had introduced Holmes to the literary world in 1887 in "A Study in Scarlet." Over the next few years, the character's popularity would grow with the publication of subsequent books and short stories, but Doyle soon grew tired of the London detective who lived at 221B Baker Street and endeavored to do away with him once and for all—"even if I buried my banking account with him," he wrote in his autobiography.[1]

With uncharacteristic cruelty, Doyle killed off his most famous creation, leaving poor Dr. Watson—Holmes's sidekick and narrator of all but four of his stories—"dazed with the horror of the thing."

Doyle, however, felt little remorse. "If I have sometimes been inclined to weary of him, it is because his character admits of no light or shade," he said of Holmes. "He is a calculating machine, and anything you add to that simply weakens the effect."[2]

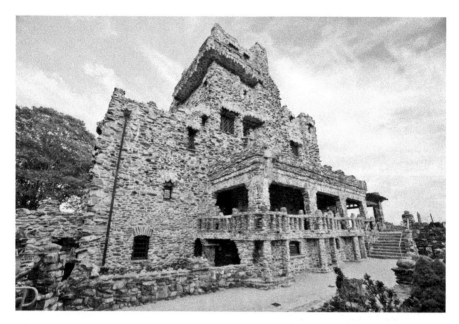

A modern-day look at the exterior of Gillette Castle. *Courtesy of Connecticut's Office of Tourism.*

Doyle meant for Holmes's death to be permanent. In fact, the character seemed destined to fade out of the public consciousness like many once-popular literary detectives who had come before him, including Edgar Allan Poe's C. Auguste Dupin, a possible inspiration for Holmes.

Yet Holmes was not destined for the dustbin of history. He narrowly escaped that fate thanks to an actor on the other side of the Atlantic, an actor whose once-legendary performances have been all but forgotten outside theater history circles but whose reinvention of Holmes helped transform the detective from a deceased and short-lived character into a cultural phenomenon that has survived for more than one hundred years and is destined for immortality.

That actor also left a mark on the character that has been unintentionally imitated by every actor to portray him—from Basil Rathbone to Robert Downey Jr. and Benedict Cumberbatch. Along the way, this actor amassed a great enough fortune to build a Connecticut castle unlike any mansion that has been built before or since, a place that a century after its creation is still full of mystery.

William Gillette never called it a castle. Instead, the famous actor referred to the striking monolith of steel and stone that had sprung, as if by magic, from his wild imagination between 1914 and 1919 as his "Hadlyme Stone Heap."

For later generations, there was no mistaking the majesty of the fourteen-thousand-square-foot, twenty-four-room structure. It was, is and always will be a castle.

Purchased at a discounted price by the State of Connecticut in 1943 and thereafter known as Gillette Castle, the edifice has attracted generations of architecture lovers, Sherlock Holmes enthusiasts and adventurers of every shape and size on their individual quests of curiosity.

In 2014, Bill Mattioli, then supervisor of the state park that straddles the towns of East Haddam and Lyme, estimated the site attracts about 300,000 visitors a year, making it one of Connecticut's most popular tourist attractions. Walking the grounds of the castle, one understands the siren of these summer sojourns and fall day trips. Rising on the crest of one of seven hills overlooking the Connecticut River, the castle is a sight to behold. With its white fieldstone exterior and block-shaped towering turrets, it is, to quote Humphrey Bogart from *The Maltese Falcon*, "the stuff that dreams are made of."

Seeing the place for the first time, some guests become a little overexcited and forget their knowledge of world history. "No, King Arthur never lived here, and no, he didn't pull the sword out of the rock here," Mattioli explains with a laugh.

There also are myths of a different sort surrounding the castle. Seeing the obvious wealth necessary for the castle to be built, many assume that Gillette's fortune is associated with the Gillette razor blade company; it is not. The founder of the razor company was merely a distant relative and not the source of William Gillette's considerable assets. The actor's money came from his work on the stage.

The castle may have a fairy-tale exterior, but its interior has a turn-of-the-century, technologically innovative feel that could be called steampunk, if the castle did not predate usage of that term by some time. Gillette was an incessant tinkerer and inventor who had filed several successful patents, including a new method for more accurately simulating the sound of a galloping horse during plays. His castle remains full of these sometimes ingenious, sometimes wacky, but always entertaining innovations. It was the first house in the area powered by electricity—giant electrical handles still adorn the castle walls—and the first with running water. But these ultramodern amenities were merely the beginning of the oddness of the house.

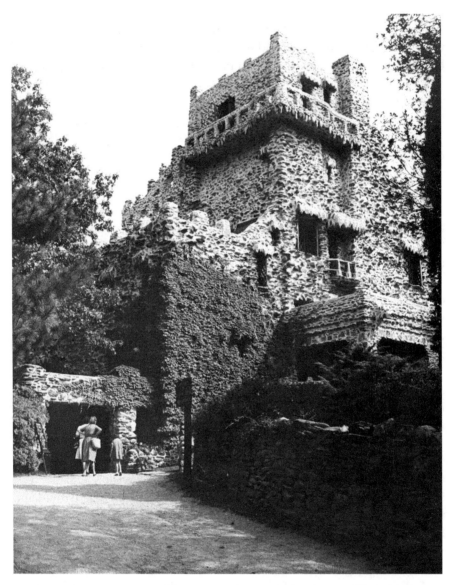

Gillette Castle exterior. *Courtesy of Connecticut's Department of Energy and Environmental Protection.*

There are forty-seven intricately carved doors, each one different from the others and each with a wildly complex series of twisting pulleys and turning wooden handles that perform the rather pedestrian task of turning the doorknob. There are chairs on sliders and secret passages and rooms, as well as a series of spy mirrors that allowed Gillette to observe his guests without being seen and play a variety of famous pranks on them. Around

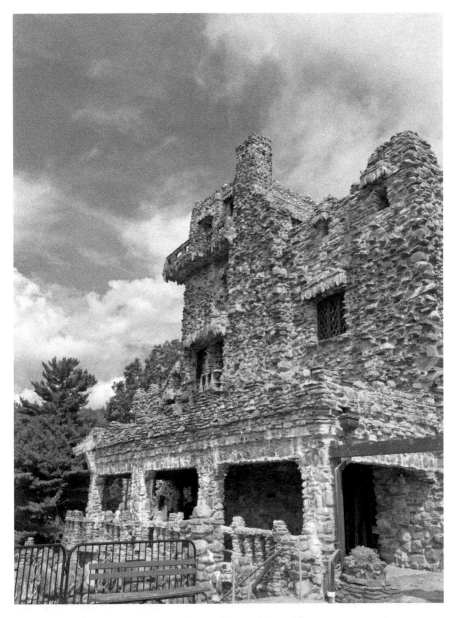

Gillette Castle exterior in September 2015. *Photo by Corinne Ofgang.*

the property there is a path that once served as the tracks for a miniature train with which Gillette terrified guests—including Helen Hayes, Charlie Chaplin and Albert Einstein—by whirling them near the cliffs above the river at breakneck speed. At its height, this little train had more than three

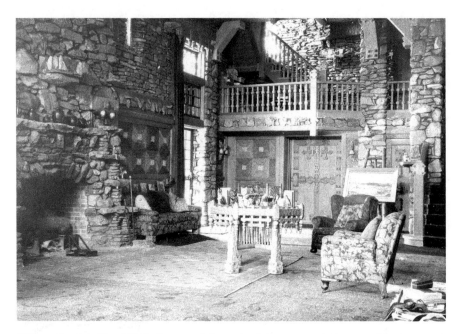

Gillette Castle's Great Hall. *Courtesy of Connecticut's Department of Energy and Environmental Protection.*

miles of track, including a tunnel, a swing bridge and two terminals. The tracks are no longer present on the castle grounds, but one of the two original locomotives has been beautifully restored and can be seen in the park's visitor center.

With all the strangeness of the place, it's no wonder that it has amassed some haunted rumors over the years. But to Sherlock Holmes enthusiasts—Sherlockians, as many call themselves—the place is inhabited by a spirit of a different sort: the spirit of the Baker Street detective who was resurrected by Gillette and seems to lurk within every corner of the castle. In researching this book, I have searched for that spirit and the clues to the creation and true character of Sherlock Holmes offered at Gillette Castle. I also have been mindful of clues regarding the personality of the man behind the curved pipe himself, William Gillette.

Eccentric is a word often used to describe Gillette, and it is both accurate and something of an understatement. At one time, Gillette had as many as seventeen cats living with him at the castle. In addition to whirling his train around the property, he also had a motorcycle that he rode at equally dizzying speeds into his seventies—once becoming involved in a nearly fatal crash.

Despite his considerable fame on the stage and his lavish lifestyle off it, surprisingly little is known about Gillette's personal life. He let few people into his inner circle and burned most of his letters and personal correspondence before his death, as biographer Henry Zecher has noted. "He kept no journal, granted rare interviews and allowed only a privileged few inside his carefully constructed and studiously maintained reserve," Zecher wrote. "His life remains a greater mystery than any presented on the stage. Few knew him then, none know him now," and "he wished most of all that no one would ever know his secrets."[3]

In my attempt to tell the story of Gillette Castle, I could not help but delve deeper into the mystery of the castle and could not do so without learning more about Gillette himself and about the life and death of his oh-so-very-famous alter ego. In doing so, I've encountered the sometimes-blurred line where Holmes began and Gillette ended, for rarely has a literary character been so closely linked to the persona and appearance of a living person. And rarely does the home of a person lend such insight into its owner's persona.

The story of Gillette Castle is the story of William Gillette, and the story of William Gillette is the story of Sherlock Holmes. In the pages that follow, you will find not just history of Gillette Castle but also a closer look at the personalities of both Gillette and Doyle and the character the latter created and the former brought to life. It is a tale that is at its heart a mystery—a mystery of a building and its quirks, of a man and his eccentricities and of the birth of a character the world will never forget.

PART I
THE ACTOR AND THE WRITER

1

William Gillette

He had power within him.

That's what William Gillette's aunt Isabella Beecher Hooker believed. Putting her hands on his eyes, she felt the stirrings of the spirit world, and she believed Gillette could be a great medium.

Isabella—the wife of John Hooker, brother to William's mother, Elisabeth—was an early champion of women's rights who worked hand in hand with legendary suffragists like Susan B. Anthony and Elizabeth Cady Stanton.

In 1876, she came to believe that by the year's end, she would "be called to the presidency of a matriarchal government, which would spread from the United States across the whole world and under her leadership be merged with the kingdom of Christ in a great millennial period."[4]

Isabella was wrong about her vision of her own world leadership, but she proved only half wrong about William. He did not grow to be a medium, but he certainly had power, only he would cast his spell on the living, not the dead.

———————

William Gillette was born in Hartford on July 24, 1853, to a wealthy family with considerable prestige and influence. On his mother's side, Will, as he was called throughout his childhood, was a descendant of Thomas Hooker, "the father of Connecticut," a Puritan colonial leader who founded

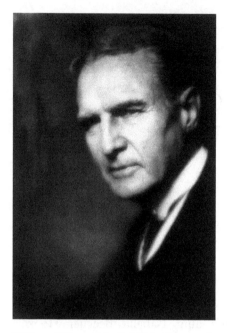

William Gillette, July 6, 1918. *Courtesy of Wikimedia Commons.*

Hartford and was instrumental in drafting the "Fundamental Orders of Connecticut," often regarded as one of the first written constitutions in history.

William's father, Francis, was a U.S. senator and an advocate for the abolition of slavery, public education, women's suffrage and temperance. He campaigned to have the word "white" removed from Connecticut's constitution and operated a station on the Underground Railroad.

In 1853, Francis purchased a tract of land in Hartford with his brother-in-law John Hooker. Over time, they began selling lots of land to their friends and relatives, creating the Hartford neighborhood of Nook Farm. The "Nook" would become a modern-day Camelot of literary greats and progressives and the fertile breeding ground on which Will's creativity grew. The neighborhood was home to Mark Twain; Harriet Beecher Stowe, author of *Uncle Tom's Cabin*; Charles Dudley Warner, an essayist and novelist who cowrote *The Gilded Age: A Tale of Today* with Twain in 1873; Joseph Twichell, a famous preacher and one of Twain's closest friends; and Isabella Beecher Hooker, the spiritualist and suffragist who saw great things in Will's future.

Joseph S. Van Why wrote, "The beauty of Nook Farm's stately trees and gently rolling terrain, which sloped toward the Park River, gave it a distinctly rural appearance, akin to the English countryside. Its spacious Victorian homes stood amid carefully landscaped grounds that merged imperceptibly into each other to create the effect of an extensive park. The hospitality, energy, brilliance and accomplishments of its residents brought Nook Farm renown and gave to it an aura of fascination."[5]

Over time, many of the Nook's most famous residents would start to wander off, but it continued to have influence. It was the childhood home of legendary screen actress Katharine Hepburn, and her parents carried on the progressive legacy of the area. Her father, Dr. Thomas

Hepburn, was one of New England's first urologists, and her mother, Katharine Martha Houghton, was president of the Connecticut Suffrage Association.

Today, the neighborhood is home to the Mark Twain House & Museum (where guests can tour the home of the famous author), as well as the Harriet Beecher Stowe Center, which also serves as a museum.

It is easy to imagine a young Will sharpening his wit by trading barbs with Twain, a close family friend, and ultimately developing the tongue-in-cheek sense of humor that would remain with him throughout his life.

One of six children, Will was the youngest Gillette son and had little company from his siblings growing up. His eldest brother, Frank, went to California and died of tuberculosis in 1859. His brother Robert joined the Union army and died in the Civil War.

In 1863, his brother Edward moved to Iowa, and his sister Elisabeth married George Henry Warner, making Will the only child in the Gillette home (another sister had died as a child). Being alone in a house in a neighborhood of intellectual giants may have encouraged Will's intellect to run wild. For even at a young age he was already fascinated with the passions that would stick with him later in life and which are on display at Gillette Castle: theater, the arts, engines and all things mechanical.

———•———

In 1866, there began to appear in Hartford in limited circulation a newspaper called *Hail Columbia*. It included among its contributors some of the city and state's most respected figures, including Charles Dudley Warner and Francis Gillette. It was an impressive feat, considering the paper's publishers were thirteen-year-old William Gillette and his friend H.W. French.[6]

It was far from the only entrepreneurial activity William undertook in his childhood. His first forays into the world of theater were elaborate puppet shows he put on for his friends. To create the backgrounds to these productions, he stripped landscape paintings from the walls of his parents' house. It was in these early shows that Will developed his love of performing. In 1900, Richard Duffy vividly reimagined these early performances:

> *Can't you see him there, thin and over-tall for his age, jumping and skipping from side to side of the tiny stage in order to manipulate the invisible black thread that is the artery of life to his characters? The wide-*

eyed, rosy-cheeked audience of five or ten playmates, induced to attend only because it is a rainy day, sits wonderingly before the incomprehensible achievements of the master magician.... [When the show is over] *the audience disbands in disorder. But the ill-starred stage manager gathers his tiny scene and the puppets tenderly to their box...and listens to the steady roar of the rain on the roof, childish imagination, like the fire of the East, lights up the apotheosis of his little theater. He stands before a curtain that towers above him as he towers above his paper scene, and the roar of the rain on the roof swells and swells in volume till it deafens his ears. It is not rain; it is applause.*[7]

By age sixteen, William had built a stationary steam engine in the third floor of his family's home. He also staged more elaborate plays within the Gillette carriage house with another Hartford boy, Otis Skinner, who was also destined to grow into a famous stage actor.

Theater was not an entirely respected pursuit for a wealthy gentleman at the time, and initially, Francis Gillette did not even want his son seeing any productions save for Shakespearean plays. When *The Colleen Bawn* by Irish playwright Dion Boucicault came to Hartford, Will and his cousin used the same printing press they used to print *Hail Columbia* to create a flyer that credited William Shakespeare as the author of *The Colleen Bawn*. Years later, Gillette told the *New York Times*, in a rare interview, that his father had seen through the ruse but "had let us go to the play because he really admired our sublime nerve!"[8]

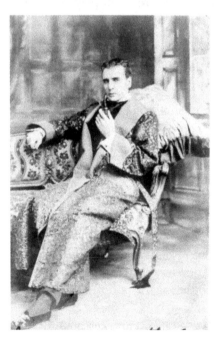

William Gillette as Sherlock Holmes. *Courtesy of Wikimedia Commons.*

Despite his misgivings about the theater, Francis had a love of oratory. In February 1855, he spoke before the U.S. Senate and railed against the horrors of slavery. "In what article, section, or clause, of the Constitution is the tremendous power given to this Government to make a man a slave, to snatch from him the crown and jewels of his immortal nature, and

load him with chains?...Slavery, as it is well understood, deprives persons of life, liberty, and property."[9] Elsewhere in the same speech, he bemoaned the laws under which "several persons...not having been claimed as slaves and therefore presumed to be free, have been sold into Slavery for life. Thus the Government sells its own citizens into Slavery, as cannibals sometimes eat their own children."[10]

This oratory passion would inspire Will in later years, and it was his father who taught him his most important acting lesson.

When Will entered an elocution contest at Hartford Public High School in his junior year at the school, he read a part of Daniel Webster's famous reply in the senate to Robert Hayne. "I had worked very hard on it, and I did it as well as I could, and I won the first prize, and when it was over I hurried out to find my father and see what he thought," recalled Gillette in 1914, when his fame had been well established. Instead of being pleased as Gillette had expected, his father seemed disappointed, even angry. "Didn't I do it right?" Gillette asked. Francis responded, "Right! Of course you did it right! That's what was the matter with it! Do you suppose if Webster had done it 'right' any one in the Senate would have listened to him for two minutes?"

Francis then told Will how the speech was actually delivered by Webster. How Hayne had started to talk when Webster was not in the room, "and how Webster's friends had sent for him and he had came running in in a hurry, all unprepared and answered Hayne. He made me see Webster, all eager and uncertain, hunting for the right words, searching for the thing to say and the strongest way to say it, hesitating, going on—"

Gillette's father told him he had "reeled that oration off so that every one would know I had just 'learned my lines,' that I had all the correct pauses and gestures and manners and intonations, and that I had made the whole thing meaningless."

The episode had a profound effect on Gillette. "I never forgot it. I never forgot that a word was a fine thing that must be searched for, and that the way to make a speech was not in the way that was 'correct' as elocution, but the way that the man actually made it in the first place."

The next year, he chose another speech by Webster for the competition, and someone else won. "They said I didn't know my lines," Gillette said. But he was not dismayed; his father's advice had forever altered his oratory style, and for Gillette, there was no looking back. As he would later recall:

I think of that scene with my father to this day. I think of it when I'm playing and when I'm studying a part and when I try to say anything about

the development of acting in the last forty years. That old New England Gentleman had the idea that has come to be the controlling idea on the stage today—in spite of the intellectual critics who mourn the passing of "the way to read blank verse." The idea is that we are not reciting literature—not reciting anything that has ever been written or said before; we are talking, saying the first things that come into our heads, thinking them out as we say them, hesitating and wondering and sometimes blundering over it all. That is the way to recite Webster's speeches; it is the way to play Shakespeare; it is the way to do everything on the stage.[11]

In his acting treatise, *The Illusion of the First Time in Acting*, Gillette would expand on this notion:

Unfortunately for an actor (to save time I mean all known sexes by that), unfortunately for an actor he knows or is supposed to know his part. He is fully aware—especially after several performances—of what he is going to say. The character he is representing, however, does not know what he is going to say, but, if he is a human being, various thoughts occur to him one by one, and he puts such of those thoughts as he decided to, into such speech as he happens to be able to command at the time. Now it is a very difficult thing—and even now rather an uncommon thing—for an actor who knows exactly what he is going to say to behave exactly as tho he didn't; to let his thought (apparently) occur to him as he goes along, even tho they are there in his mind already; and (apparently) to search for and find the words by which to express those thoughts, even tho these words are at his tongue's very end. That's the terrible thing—at his tongue's very end![12]

After high school in Hartford, Gillette, at the age of twenty, had the "fever to go away from home and swim out." His dream was to find his way in the world as an actor. His family wished to send him to Yale but supported his pursuit of his dream. "My father let me have my way. He liked oratory very much, and spoke well when he needed to, though he was rather a silent man."

The day Francis took his son to the train station, he made a dire plea. "He had taken two of my brothers on the same errand before me. One went to California and died there; the other was killed in the war. 'William,' he said, 'you're the third son I've driven to the train like this. The others have never come home. I trust you will prove an exception.'"

Gillette Castle exterior. *Courtesy of Connecticut's Department of Energy and Environmental Protection.*

Gillette traveled to St. Louis, "just as far" as his money would take him. There he endeavored to enter the theater industry any way he could. "I got my first job because I told the man I didn't want any salary, only the job."[13]

It was a small but significant first professional step for one of the greatest stars in the stage's history and one that would ultimately lead to the creation of the Connecticut castle this book is about. It also set young Gillette on a collision course with the soon-to-be famous detective from Baker Street. For around the same time Gillette made this first foray into the world of theater, on the other side of the Atlantic a young Scottish medical student was about to come face-to-face with the real-world inspiration for literature's most famous investigator.

2

Arthur Conan Doyle

His name was Joseph Bell, and he knew things he shouldn't have.
The medical doctor and instructor at the University of Edinburgh Medical School was celebrated for his skills as a physician, including his powers of diagnosis, and for his seemingly magical ability to discern intimate details about a person's history from merely looking at them.

Once, the doctor, who was thin and dark with penetrating gray eyes and a high, discordant voice, instantly declared a patient either a cork-cutter or a slater. "I observe a slight callus, or hardening on one of his forefingers, and a little thickening on the outside of his thumb, and that is a sure sign he is either one or the other," he said.[14]

"Ah!" he once said to another man. "You are a soldier, a non-commissioned officer, and you have served in Bermuda?…How did I know that?…He came into our room without taking his hat off, as he would go into an orderly room. He was a soldier. A light authoritative air, combines with his age, shows he was an NCO. A slight rash on the forehead tells me he was in Bermuda, and subject to a certain rash known only there."[15]

Bell urged his students to try to observe their patients without touching them. "Use your eyes! Use your ears, use your brain, use your bump of perception, use your powers of deduction," he told them. He admonished one student for incorrectly diagnosing a patient with a limp as having hip-joint disease. "Hip nothing!" Bell said. "The man's limp is not from his hip but from his foot, or rather from his feet. Were you to observe closely you would note that there are slits—cut by a knife—in those parts of the

shoe in which the pressures of the shoe is greatest against the foot. The man is suffering from corns, gentleman, and has no hip trouble at all." Bell took things yet a step further with this patient, declaring, "He has not come to us to be treated for corns.... His trouble is of a more serious nature. This is a case of chronic alcoholism. The rubicund nose, the puffed and bloated face, the bloodshot eyes, the tremulous hands and twitching face muscles, with the quick, pulsating temporal arteries, all combine to show us this."[16]

Many of his students were in awe of these skills, but none more so than a young medical pupil with an eye for detail and a gift for describing the world.

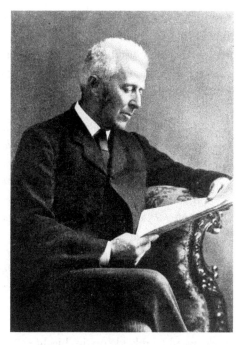

Dr. Joseph Bell, whose powers of observation inspired Arthur Conan Doyle to create Sherlock Holmes. *Courtesy of Wikimedia Commons.*

This aspiring doctor was profoundly influenced by his teacher's deductive abilities, later recalling, "He would tell them [patients] their symptoms, he would give them details of their lives, and he would hardly ever make a mistake."[17]

Had he never invented Sherlock Holmes, Arthur Conan Doyle's life would still have been extraordinary. Born in 1859 in Edinburgh to Charles Altamont Doyle, an Englishman of Irish Catholic heritage, and Mary, who was Irish Catholic, Doyle's early life was rocked by his father's battles with alcoholism, which often disrupted his family life. Despite this, at a young age, Doyle developed the hardworking attitude, zest for adventure and ability to describe it all that would ultimately help make him world famous.

In 1880, during his third year of medical school, he signed on as ship's surgeon on the *Hope*, a steam-powered whaleship bound for the Arctic

Circle. In the Arctic, he earned the nickname of "the great northern diver" after falling into the sea five times in four days, once almost fatally, while helping the crew hunt seals on the ice floes.

Later, in an article for *Strand Magazine* entitled "Life on a Greenland Whaler," he described the voyage:

> *The peculiar other-world feeling of the Arctic regions—a feeling so singular, that if you have once been there the thought of it haunts you all your life—is due largely to the perpetual daylight. Night seems more orange-tinted and subdued than day, but there is no great difference.... After a month or two the eyes grow weary of the eternal light, and you appreciate what a soothing thing our darkness is.... The perpetual light, the glare of the white ice, the deep blue of the water, these are the things which one remembers most clearly, with the dry, crisp, exhilarating air, which makes mere life the keenest of pleasures. And then there are the innumerable seabirds, whose call is for ever ringing in your ears.* [18]

It was far from the only adventure Doyle would embark on in his life. In 1893, by then a famous author, he helped popularize skiing in Switzerland. Doyle had learned to ski in Norway and felt it was perfect for the Swiss region. He began working with two Swiss skiing enthusiasts named Tobias and Johann Branger, and together the trio brought the sport to the country. Prior to the introduction of skiing, the Swiss traveled in the winter on snowshoes or with sleds.

In 1900, at the age of forty, Doyle volunteered to serve as a doctor for British troops on the front lines of the Boer War in Africa. The experience inspired his seminal work of nonfiction, *The Great Boer War.*

In two high-profile cases in the early 1900s, Doyle would channel

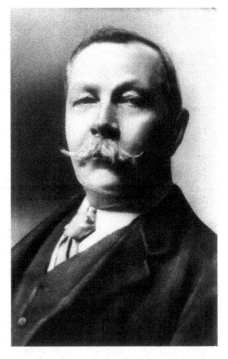

Arthur Conan Doyle, June 1, 1914. *Courtesy of Wikimedia Commons.*

30

his inner Sherlock and help shed new light on real crimes. The first case was that of George Edalji, a member of a Parsi family living in a South Staffordshire village who was sentenced to hard labor after being charged as the culprit in a series of bizarre animal mutilations that occurred in South Staffordshire at night. After researching the case, Doyle became convinced the evidence was faulty against Edalji and that his conviction had been motivated by racism. When Doyle met with Edalji, with the observation skills of Holmes and his former teacher Bell, he immediately realized that Edalji was nearsighted, which Doyle believed demonstrated he could never have perpetrated the crimes he was accused of at night.

Doyle even went a step further, finding an alternate suspect who lived in the area. This person had demonstrated cruelty to animals and had a documented grudge against Edalji and thus the motivation to frame him. Doyle's tireless championing of the case ultimately led to Edalji's being pardoned of the crime.

The second case Doyle championed was that of Oscar Slater. A Jewish immigrant and illegal gambling den operator, Slater was charged in the murder of an eighty-two-year-old woman named Marion Gilchrist who was brutally bludgeoned at her home in December 1908. The evidence against Slater was circumstantial, and the trial was lacking in due process. Slater was not allowed to take the stand, and an alibi he had for the night of the murder was refused. Investigators had zeroed in on Slater because he had been seen in the area of the murder—not surprising since he lived two blocks away. In addition, witnesses reported he pawned a diamond brooch similar to the one taken from Gilchrist's apartment. However, Slater had pawned the brooch well before the murder and had a receipt proving as much. Nevertheless, he was arrested and, at the time of the arrest, was found with a tack hammer that authorities claimed was the murder weapon.

Slater was convicted and sentenced to death, but the sentence was ultimately commuted to life in prison. Doyle did not like Slater, who was a petty criminal and possibly a pimp, but after researching the case, he became convinced of his innocence and published a pamphlet called *The Case of Oscar Slater* in August 1912. The pamphlet pointed out many problems with the prosecution's case and demonstrated that the tack hammer Slater was found with was too light to inflict the wounds Gilchrist died from, never mind the fact that there was no blood on it.

After publishing the pamphlet, Doyle lobbied on Slater's behalf over the years. In 1927, thanks to the efforts of Doyle and others, Gilchrist's former maid made a new statement naming a man she had seen leaving Gilchrist's

apartment. Evidently, she had already told the police of this man in her initial testimony, but they had chosen to ignore her.

Shortly afterward, Slater was freed, supposedly for good behavior but more likely to avoid further bad publicity. Even so, he was not pardoned or given reparations for his years spent incarcerated. Doyle helped pay Slater's legal fees for a retrial but had a falling out with Slater after Slater won and did not reimburse him with the money he had been compensated.

Beyond successfully playing detective, Doyle made headlines in his later life for his fervent support of spiritualism. The spiritualist movement was popular in the early 1900s but had few proponents as well known as Doyle, who was one of its fiercest and most high-profile champions. Doyle famously clashed with the magician and spiritualist debunker Harry Houdini. When it came to spiritualism, Doyle often threw out much of the close observation skills and healthy skepticism that had served him so well in the cases of Slater and Edalji. It was a lapse of logic that would have made his most famous creation cringe.

———

It was not long after Doyle graduated from medical school in 1881 that the most significant milestone of his writing career occurred.

His practice as a physician started sluggishly. Patients were few and far between, and he struggled to make a living. To supplement his meager earnings, he wrote in his spare time. His early short stories began appearing in a variety of English magazines, most frequently a monthly called *London Society*. But even on days when his medical practice was busy, Doyle was able to make progress with his writings. Doyle biographer Martin Booth wrote, "He had the enviable knack of being able to drop a story in mid-sentence when the doorbell sounded, then pick it up again the minute the interruption was past. Additionally, the original material set down was largely unchanged, for his manuscripts show few corrections or alterations."[19]

Jerome K. Jerome wrote that Doyle "would sit at a small desk in a corner of his own drawing-room, writing a story, while a dozen people around him were talking and laughing. He preferred it to being alone in his study. Sometimes, without looking up from his work, he would make a remark, showing he must have been listening to our conversation; but his pen never ceased moving."[20]

It was in this period when the memory of Bell came to him, wrote Vincent Starrett, one of the first scholars of the Holmes literary canon.

"Waiting and smoking in his sitting room at South Sea for the patients that seldom came, young Dr. Conan Doyle heard again the strident voice of his former mentor, haranguing the awkward students of Edinburgh's School of Medicine. In one familiar and oft-repeated apothegm...'From close observation and deduction, gentleman, it is possible to make a diagnosis that will be correct in any and every case. However, you must not neglect to ratify your deductions, to substantiate your diagnosis."[21]

While Bell may have been the biggest inspiration for Sherlock Holmes, he was not the only one. Doyle was also influenced by the real-life tales of Eugène François Vidocq, the legendary French detective and the father of modern criminology. A former criminal, in the early 1800s Vidocq became the first director of the French National Police Force and is believed to be the world's first private detective, as well as the first investigator to compile a criminal database. Like Holmes, he had a penchant for disguise and employed an underground network of informants.

Vidocq's memoirs helped inspire the mystery writings of Edgar Allan Poe. In the early 1840s, around the time when the term "detective" first gained widespread use in the English language, a series of Poe stories were published that would help create the mystery genre. These stories included "The Murders in the Rue Morgue," "The Purloined Letter" and "The Mystery of Marie Roget." They celebrated the skills of a logical and astute observer named C. Auguste Dupin.

Doyle was smitten with these stories. In the very first Holmes story, Doyle even references Dupin. Not long after Watson and Holmes meet, Watson remarks to Holmes, "You remind me of Edgar Allan Poe's Dupin," to which the detective replies, "No doubt you think that you are complimenting me in comparing me to Dupin. Now, in my opinion, Dupin was a very inferior fellow....He had some analytical genius, no doubt; but he was by no means such a phenomenon as Poe appeared to imagine."

In real life, Doyle was more gracious. Asked in 1894 if he had been influenced by Poe, he replied, "Oh, immensely. His detective is the best detective in fiction....I make no exception. Dupin is unrivalled. It was Poe who taught the possibility of making a detective story a work of literature."

Many years later, in 1930, while Gillette—who had become fully linked to Holmes at that point—was passing through Baltimore, he received a cable from Doyle asking him to lay a wreath in both their names at Poe's grave in the Westminster Burial Ground. This was to honor the father of the detective story, and Gillette happily complied with the request.

Doyle began writing the first Holmes novella in 1886 and finished it in about three weeks. First he called it "A Tangled Skein" but quickly changed the name to "A Study in Scarlet."

He submitted it to *Cornhill Magazine*, where it was rejected because it was too short for serialization and too long for a single issue. The story was rejected by several more publishers before being picked up by Ward, Lock & Company. The work appeared as part of *Beeton's Christmas Annual*, a magazine published each year. The issue sold out; however, *Beeton's* always sold out, so the magic effect Holmes had on readers was not immediately clear.

The first story introduces the iconic character of Holmes and sets up Dr. Watson as his well-meaning but sometimes intellectually challenged sidekick. It has many of the classic elements of a great Holmes story, and readers were hooked.

"A Study in Scarlet" was reissued as a stand-alone book in July 1888, and an American edition was published in 1890. In the summer of 1889, Doyle, perhaps influenced by the steady stream of Holmes-related fan mail he had begun to receive, along with the promise of financial gain, agreed to write another Holmes story for the American publication *Lippincott's Monthly Magazine*. This novella was called "The Sign of the Four."

Over the next three years, in addition to this second Holmes novella, Doyle would publish two collections of Holmes short stories. These stories and their intense popularity secured Holmes a place in literary history, but the character had not yet fully matured. Prior to Gillette's portrayal of Holmes, the detective of the page was a calculating creature of logic, an unfeeling Vulcan before Gene Roddenberry wrote *Star Trek*.

In "A Study in Scarlet," before Watson is introduced to Holmes for the first time, another character describes him as "a little too scientific for my tastes—it approaches to cold-bloodedness. I could imagine his giving a friend a little pinch of the latest vegetable alkaloid, not out of malevolence, you understand, but simply out of a spirit of inquiry in order to have an accurate idea of the effects."[22]

As a result of these qualities, Doyle had little love for the creation of his pen. "Sherlock is utterly inhuman, no heart, but with a beautifully logical intellect."[23] It would take an eccentric actor from Hartford to play Dorothy to Holmes's Tin Man and give this unfeeling sleuth a heart.

3

Gillette at the Theater

As Doyle was being stunned by the observational powers of Dr. Bell, Gillette was getting his start on stage in America. It was the 1870s, and the theater was emerging from literal dark ages. It was only a few decades earlier that gaslight had replaced candlelight as the main form of illumination, and the still somewhat dimly lit American stages were often bawdy places that struggled for respectability. As theater producer Richard D'Oyly Carte observed in 1881, "The greatest drawbacks to the enjoyment of the theatrical performances are, undoubtedly, the foul air and heat which pervade all theatres. As everyone knows, each gas-burner consumes as much oxygen as many people, and causes great heat beside."[24]

This early theater, filled with the sweat of audience members and performers alike and thick with the unpleasant scent of burning gas, was a paradise for Gillette. He was a young Hartford gentleman with a striking appearance and gifts for elocution and mechanical ingenuity, and these qualities served him well in his chosen profession. In New Orleans in 1873, he played the role of an Indian in *Across the Continent*, a melodramatic mix of comedy and musical. Within the year, he received his first speaking part in St. Louis.

Though enchanted by the stage, Gillette was unhappy with the melodramatic style of acting that was popular. He wanted to speak his lines in the natural manner his father had taught him, "but they wouldn't let me," he later recalled. "I began very humbly indeed, in stock, and if I had tried to be natural, I'd have lost my position. My business then was to

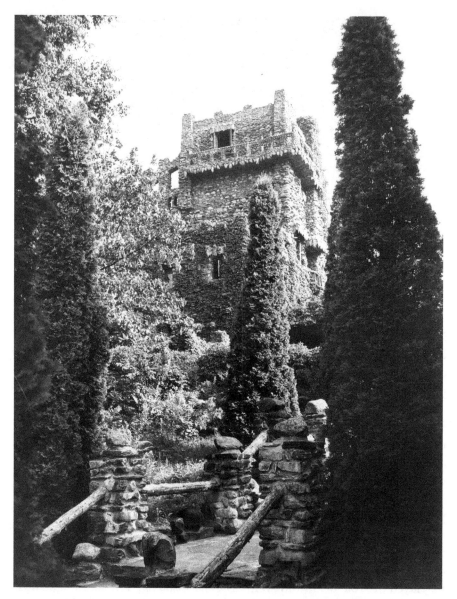

Gillette Castle exterior. *Courtesy of Connecticut's Department of Energy and Environmental Protection.*

learn the tricks of the stage. We had our tragic walk, our proper comedy face, our correct and dreadful laugh, our carefully learned gestures, our shrieks and outcries and our stilted voices."[25]

Artistic compromise was not Gillette's only problem. His pay for these early productions was meager to nonexistent. He was even fired from his

St. Louis production company when he had the audacity to request a salary of any kind.

After moving on from New Orleans, Gillette met the legendary American stage actor Edwin Booth, whose signature role was Shakespeare's Hamlet. Booth's success on the stage allowed him to commission his own theater, Booth's Theater, on Sixth Avenue in New York City. (This theater was demolished in 1883; the Booth Theater still standing on New York City's West Forty-Fifth Street was built in 1913 and named in honor of the late actor.) Booth was also the older brother of John Wilkes Booth, the man who assassinated President Abraham Lincoln in 1865, but Edwin did not share his brother's rebellious political beliefs or murderous ambitions.

Booth was known for a more natural, less bombastic style of acting that was ahead of its time and lent itself particularly well to sensitive roles like Hamlet. Booth had abandoned the theatrical convention that all roles must be played big, with large arm motions and voice raised with sound and fury. It was an acting style Gillette emulated.

Gillette approached Booth, most likely after seeing a performance of *Romeo and Juliet* at Booth's theater. According to the tale, Gillette sought the wisdom of this theatrical sage and asked him about performing. Booth offered a direct piece of advice: don't. "Young man, I wouldn't," Booth said. "It's a dog's life."[26]

Gillette did not heed that advice; instead, he continued to pursue his passion for the stage, and his first big break was on the way, thanks to an old Hartford friend.

———

In 1874, Mark Twain turned his attentions from the page to the theater. *The Gilded Age: A Tale of Today*, coauthored by Twain and Charles Dudley Warner, had been published a year earlier and was met with acclaim and commercial success. Shortly after its publication, unauthorized stage adaptations began to appear. To stop this theft of his intellectual property, Twain launched his own production in New York City in September of that year.

Twain got Gillette a part in the production, but his motives for hiring his former neighbor may have been less than altruistic. According to the author Lowell Thomas, Twain did not believe Gillette had any talent and had gotten him into the cast as a joke. "I don't know which I like best—having Gillette make a tremendous success, or seeing one of my jokes go wrong," Twain reportedly said.[27]

While it is doubtful Twain would risk an important production by intentionally casting a bad actor in a role, even a minor one, it is plausible that Twain told the story as a way of playfully teasing Gillette. Either way, the role proved a boon to Gillette's career.

As the alternate for the foreman of the jury, Gillette had limited lines but made the most of them. It was "a very responsible position," he later said with mock seriousness. "Not a mere juryman you understand but the *foreman*. Just before the close of the entertainment the Clerk of the Court Asks: 'Have you agreed upon a verdict?'" Gillette's character answers, "We have!" The clerk asks whether it is guilty or not guilty; Gillette replies, "Not guilty!" After that the curtain fell and Gillette's work was done. "I called it two pages, and it was, as I arranged it—one line to a page!"[28]

Sarcastically, Gillette wondered why as a result of the play "I was not snapped up." But better roles were on the way. Over the next few years, Gillette played small but increasingly bigger parts in a variety of major productions. However, to get the parts he really wanted, he decided he needed to write them himself. In 1876, he confided in friends that he hoped to become a playwright.

Shortly thereafter, he began work on a play about an absentminded professor of astronomy at Boston University whose blundering attempts at finding love make for a comedic farce. In 1879, the play, called *The Professor*, was completed, and Gillette began performing in the title role.

It was not exactly Shakespeare.

As Gillette biographer Zecher wrote, "It had little story line, the characters acted in a nonsensical manner, and comedic effects were achieved through incident and pantomime." In preparing the play, Gillette had collected a list of three hundred lines of pun-ridden, "humorous" dialogue. These included groan-inducing gems like "My heart is broken," to which another character replies, "Well hadn't you better swallow some glue?"[29]

When the production toured Gillette's hometown of Hartford in 1880, reviews were not good. The *Hartford Evening Post* wrote, "The piece is evidently so purely amateur, both in its conception and production, that the pen of criticism is partially disarmed, and the first effort of the author must be kindly dealt with."[30]

The *Philadelphia Inquirer* was a rare paper that found something to admire in the production, calling it "bright, harmless, amusing, and altogether very enjoyable."[31]

Twain also saw something in Gillette's freshman work. He was one of the major investors in a staging of the show at the Madison Square Theater

in New York City. The theater was the most advanced of its day. Under the direction of playwright and inventor Steele MacKaye, the Madison Square Theater pioneered many technological innovations, including overhead and indirect lighting (the source was electricity not gas), moveable stages, an early form of air conditioning, improved ventilation and the folding seats found in most theaters today.

Before premiering at Madison Square Theater, *The Professor* was streamlined, lines were cut, the pantomime was increased and the visual effects were enhanced. The result was an improved production but one that still struggled with the critics. The *New York Herald* acknowledged the play's ability to make its audience laugh but criticized its ambitions as anything more than a farce. "If the object of Mr. Gillette was to make his audience laugh constantly and keep them in good humor for some two or three hours then he certainly and fully succeeded in his aim; but if he imagined that in writing 'The Professor' he was concocting an original comedy, whose pathos as well as its humor would equally move its [audience], then he must have been as sadly astray in his reckoning as was the hero of his piece in most of his calculations."[32]

The *New York Times* called it "weak and of no value," adding for good measure that it "is one of those feebly pretensious, unreal, and self-contradictory plays which show no insight into the natures of men and women."[33]

Audiences did not agree with the assessment of the critics and were happy to pay to see the play, even if it gave them no insight into "the natures of men and women."

It ran for 151 more performances in New York City and toured for 1,000 more shows. It was the first in a long line of Gillette's plays disliked by critics but embraced by the theatergoing public. From the beginning, Gillette was a populist performer with his goal being to entertain and provide joy for the audience above all else. Unlike Doyle, for whom pleasing the crowd was not enough, Gillette lived for the crowd.

Audiences could already pick up on this during his first, admittedly uneven, production. There was no pretension here. No aim but escapism. While Doyle grew to resent Holmes because of his popularity, Gillette would fall in love with the character for the same reason.

In November 1881, Gillette brought the show back to Hartford. This time, the hometown press was kinder. The *Hartford Daily Courant* had great admiration for its local hero. "Mr. Gillette's Professor is a delicious bit of character acting—he is never anything but the matter of fact man of

books, with a warm heart, but little knowledge of womankind," raved the paper. "His very seriousness in everything furnishes much of the humor of the play."[34]

The *Courant* saw in Gillette what audiences did: an actor with a natural presence, forgoing the melodrama of the day to great effect, and a playwright whose lines were written not to educate but to entertain. No longer an unpaid actor playing bit parts, Gillette was a triple-threat writer, actor and director whose name was adorning the marquees of the world's biggest theaters.

And as Gillette's career had advanced, so, too, had the American theater. The gas lamps were giving way to electricity, the ventilation was improving and other theaters would soon imitate the air conditioning offered at Madison Square Theater. The stage was becoming a better-lit, more comfortable, respectable place, and the middle class would embrace it in all its newfound technological glory.

In the limelight of this new emerging theater, no star would shine brighter than William Gillette. But as Gillette emerged as an undisputed star of the American theater, back in London trouble was brewing on Baker Street.

4

The Death of Sherlock Holmes

It is the perfect site for a murder.

In the northern Swiss Alps, within the village of Meiringen, twenty-five kilometers east of Interlaken, Switzerland's Reichenbach Falls are found. A gushing cascade of white foam and roaring water dropping a total of 820 feet, the falls were, and are, a famous sight in the region.

The falls are also far away from the Connecticut River and the future site of Gillette Castle, but it was in the beautiful, idyllic hills of Switzerland that the first steps were taken toward the building of that castle.

Doyle visited the falls in 1893, touring a bridge that spanned a deep, water-cut drop. It was a beautiful and terrifying spot that fueled the murderous thoughts already growing in his heart for Holmes.

Since the detective had debuted in 1887, Doyle had penned an additional novel and more than twenty stories featuring him. The stories see Holmes and Watson solving mysteries for the king of Bohemia, tracking down members of the Ku Klux Klan and engaging in a wide variety of other adventures.

Over the same time period, Doyle had written two historical novels, *The Refugees* and *The Great Shadow*, the latter of which he regarded as one of his strongest works. These were the types of work he wanted to focus on, but to his dismay, these books were not as popular as Holmes. "All these books had some decent success, though none of it was remarkable," he said. "It was still the Sherlock Holmes stories for which the public clamored."

Unlike Gillette, Doyle was not satisfied with pleasing the crowd. "From time to time I endeavored to supply [Sherlock Holmes stories]," he wrote, but "at

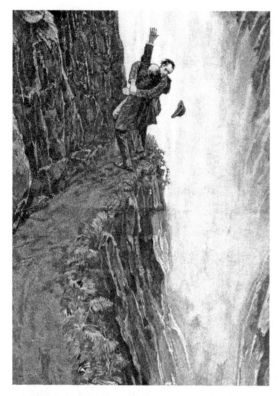

The Death of Sherlock Holmes. Sherlock Holmes and Professor Moriarty at the Reichenbach Falls. Illustration by Sidney Paget to "The Final Problem" by Arthur Conan Doyle, which appeared in *The Strand Magazine* in December 1893. *Courtesy Wikimedia Commons.*

last, after I had done two series of them I saw that I was in danger of having my hand forced, and of being entirely identified with what I regarded as a lower stratum of literary achievement."

To avoid having his writing career swallowed by the detective, Doyle decided drastic action was needed. "As a sign of my resolution I determined to end the life of my hero."

While on a vacation in Switzerland with his wife, Doyle saw the high bridge at Reichenbach Falls and decided it would be where Holmes would meet his fate. Doyle recalled that the "wonderful falls of Reichenbach" were "a terrible place and one that I thought would make a worthy tomb for poor Sherlock."

By this time, Gillette had become one of America's biggest stars but had also endured personal tragedy.

A decade earlier, when *The Professor* stopped in Detroit in 1882, Gillette spotted a striking young lady in the audience. Her name was Helen Nichols. He met her after the production, and a romance blossomed between the two. She was a charming twenty-two-year-old Detroit native with good looks, a shy and gentle manner and a passion for literature. Gillette was smitten. They were married in June of that year.

He talked passionately of his wife in letters to family members, but she seems not to have been a distraction from his work. The April after his marriage, he filed a patent for an improved timestamp mechanism for postmarking letters. He soon appeared on stage in *The Private Secretary*, a version of a German work he had also rewritten for American audiences. Like *The Professor*, it received mixed reviews, but like his first work, it was a success. He toured the country with it.

In 1886, he premiered his play *Held by the Enemy*. It was a Civil War story of espionage that followed a Confederate and a Union soldier who were both competing for the love of the same southern woman. The play remains one of Gillette's most celebrated works.

Audiences were moved by the stirring tale, and even some influential critics were forced to admit it had its merits. "Under any circumstances, and by any audience, Mr. Gillette's work would have been followed with respectful attention from first to last," said the *New York Times*. However, the *Times*'s critic did have some criticisms, noting the play was "not profound in its revelation of human experience" and that "its pathos is not deep, its humor is very trifling and elusive. Its literary merit is small." Nevertheless, this critic admitted, "It has positive merit. It tells a story of war, but its theme is the human heart, and the military trappings are left in the background."[35]

Audiences, as usual when it came to Gillette's work, were unabashed in their praise, and that's what Gillette cared most about. Rather than dismissing the public's preference as Doyle did, Gillette credited the public taste with being the driving force in the evolution of theater:

> *For the development and specialization of this great Life-Class, Drama—or whatever you may please to call it, has been slowly but surely brought about by that section of the public, which has long patronized the better class of theaters. It has had no theories—no philosophy—not even a realization of what it does, but has very well known what it wants—yet by its average and united choosing has the character of Stage Work been changed and shaped and molded, ever developing and progressing by the survival of that which was fittest to survive in the curious world of Human Preference.*[36]

And the public clearly had a preference for Gillette, who was already on his way to becoming one of the biggest stars of the English-speaking world. Offstage life was less grand. At 2:00 a.m. on the morning of September 1, 1888, Helen, Gillette's wife of just six years, died of complications resulting from a ruptured appendix. She was only twenty-eight years old. Gillette was

Historic approach to Gillette Castle. *Courtesy of Connecticut's Department of Energy and Environmental Protection.*

devastated. For a time after Helen's death, family members brought Gillette his meals, and he was often seen visiting his young wife's grave. Since the couple had no children, Gillette was alone. And alone he would remain.

Eight years later, he told the mother of a young woman who had admired him that he had made a promise to Helen that he would never remarry and could not break his word. Whether this was true or just Gillette's way of resisting the advances of an ardent admirer is not clear; either way, Gillette, who was just thirty-five at the time of his wife's death, never remarried. Any romantic interludes he may have had in the remaining decades of his life occurred away from the prying eyes of the press and the public, which was always the way Gillette preferred things.[37]

It is difficult to kill a genius. As Doyle planned Holmes's murder, he knew no ordinary criminal would be up to the deed. So he created a super villain: James Moriarty. This new criminal mastermind was Holmes's doppelganger,

every bit his intellectual equal but dedicated to perpetrating crime rather than solving it.

At the start of the bluntly titled "The Final Problem," Holmes reveals to Watson that a disgraced former professor and mathematician named Moriarty has been directing the criminal activities of much of London. "He is the Napoleon of crime, Watson. He is the organizer of half that is evil and of nearly all that is undetected in this great city," Holmes explains. "He is a genius, a philosopher, an abstract thinker. He has a brain of the first order. He sits motionless, like a spider in the center of its web, but it has a thousand radiations, and he knows well every quiver of each of them."

Holmes further reveals to Watson that he has laid a trap for Moriarty and the top members of his criminal organization that will lead to their arrest in a few days. However, Moriarty is aware of Holmes and his efforts, and Holmes's life is in grave danger. Holmes is uncharacteristically unnerved but is determined to go forward with his plans against Moriarty, proclaiming: "If I could beat that man, if I could free society of him, I should feel that my own career had reached its summit."

Holmes and Watson decide to hide out from Moriarty in Switzerland. As they leave London they are hounded by Moriarty's henchmen, but after some clever disguise work from Holmes, they believe they have given them the slip. In Switzerland, they travel by way of Interlaken to Meiringen. "It was a lovely trip, the dainty green of the spring below, the virgin white of the winter above," recounts an ever-faithful Watson, "but it was clear to me that never for one instant did Holmes forget the shadow which lay across him. In the homely Alpine villages or in the lonely mountain passes, I could still tell by his quick glancing eyes and his sharp scrutiny of every face that passed us, that he was well convinced that, walk where we would, we could not walk ourselves clear of the danger which was dogging our footsteps."

After arriving in Meiringen they stop at an inn and decide to walk to Reichenbach Falls. Watson describes the falls in ominous detail: "It is, indeed, a fearful place. The torrent, swollen by the melting snow, plunges into a tremendous abyss, from which the spray rolls up like the smoke from a burning house. The shaft in which the river hurls itself is an immense chasm, lined by glistening coal-black rock, and narrowing into a creaming, boiling pit of incalculable depth."

On the way to the falls, Watson is summoned back to the hotel by a Swiss boy to assist an English woman who has fallen ill and requires

medical attention. Holmes decides to go on to the falls anyhow, an almost comically dubious decision given the dangers they clearly faced.

When Watson returns to the hotel he learns, to his horror, that there is no sick English lady and deduces correctly that the Swiss boy was hired by Moriarty to separate Watson from Holmes. Watson rushes back to the falls but is too late; the awful deed has already been done. On the cliff pathway above the falls, he finds a note Holmes penned in his last moments explaining what transpired. In the note, Holmes informs Watson that Moriarty has trapped him on the one-way pathway. In a moment, they will engage in a physical confrontation which neither Holmes nor Moriarty will survive. "I am pleased to think that I shall be able to free society from any further effects of his presence, though I fear that it is at a cost which will give pain to my friends, and especially, my dear Watson, to you."

After recounting the note, Watson describes how "an examination by experts leaves little doubt that a personal contest between the two men ended, as it could hardly fail to end in such a situation, in their reeling over locked in each other's arms."

Watson then writes, "Any attempt at recovering the bodies was absolutely hopeless, and there, deep down in that dreadful cauldron of swirling water and seething foam, will lie for all time the most dangerous criminal and the foremost champion of the law."

There are some who say that by not producing a body and not letting Watson witness the crime itself, Doyle left himself a clear out and planned on bringing Holmes back. But proponents of this theory ignore the awkwardness with which Holmes ultimately was resurrected.

Eight years after "The Final Problem" was published, as Holmes's popularity surged anew thanks to Gillette, Doyle wrote *The Hound of the Baskervilles*, but it was framed as a prequel, with the events depicted taking place prior to those of "The Final Problem." When Doyle fully relented and brought Holmes back for real in 1905's "The Adventure of the Empty House," the explanation for Holmes's reemergence made little sense. Holmes tells Watson he successfully pushed Moriarty over the edge of the cliff but realized his henchmen were nearby and still hoping to kill him. So, Holmes decided to fake his own death, the better to track Moriarty's men. Holmes kept up the farce for three years. Though Holmes confided in his brother, Mycroft, who continued to pay for Holmes's Baker Street apartment, he did not tell Watson of his survival. This seems extremely callous and outright cruel, even by Holmes's standards. And reading "The

Final Problem" and "The Adventure of the Empty House" back to back, one does not get the sense of continuity to be expected if it was all part of Doyle's master plan.

Those who think Doyle never intended to kill Holmes also ignore Doyle's own writings both at the time and in retrospect. "There [at Reichenbach Falls] I laid him, fully determined that he should stay there," Doyle wrote in his memoirs.[38]

Like Agamemnon slaying his daughter, Doyle had killed his most beloved creation, and the Baker Street detective was never meant to come back.

5

Rebirth

When Doyle threw Holmes into the rushing falls in the village of Meiringen, he was not quite prepared for the backlash the act caused. "The Final Problem" appeared in *Strand Magazine* in December 1893, hitting readers like an icy gust of winter's wind. Angry fans wrote scores of letters, venting their frustration in ways that astonished Doyle.

"I was amazed at the concern expressed by the public. They say that a man is never properly appreciated until he is dead," the author wrote, "and the general protest against my summary execution of Holmes taught me how many and how numerous were his friends." One letter to Doyle began simply, "You Brute!" and the author said he "heard of many who wept."[39]

There were further ramifications. According to some accounts, more than twenty thousand people canceled their subscriptions to *Strand Magazine*. Another tale tells of women and men taking to the streets in black armbands to mourn their fallen literary hero. Although this latter account is often repeated, no firsthand evidence of it could be found in the research of this work, and the story is most likely apocryphal.

Regardless of whether they wore armbands in mourning, readers were clearly upset by the death of Holmes. Doyle, though aware of these feelings, was unmoved. "I fear I was utterly callous…only glad to have a chance of opening out into new fields of imagination, for the temptation of high prices made it difficult to get one's thoughts away from Holmes."[40]

It was around this time that Gillette began work on what would be his most successful pre-Holmes production and the one many believe to be his crowning literary achievement: *Secret Service*. The play, which debuted in 1895, is a harrowing Civil War drama, full of drama and intrigue. With its tense action, short, terse dialogue and the realistic sets and special effects Gillette's productions were known for, the play was a commercial as well as critical success.

The *Hartford Courant* wrote in October 1896 that it was "the hit of the season in New York City and is sure to run there all winter." The same article could not resist quoting at great length from a review written by the critic Edward A. Dithmar in *Harper's Weekly* that was effusive in its praise of Gillette: "I can say without hesitation that it has never been equaled by a native playwright. In the technical excellence of its construction, no play of its kind I have ever seen approaches it. For here Mr. Gillette applies, with amazing success, the natural dramatic method of Augier, Dumas…and Pinero in modern comedy, and Ibsen in his 'social dramas,' to the development of what is commonly called melodrama." Dithmar went on to describe how Gillette had masterly done away with many of the affectations of the genre. "The 'aside' and soliloquy, traditional expedients of the poetic drama, are avoided. Nothing is

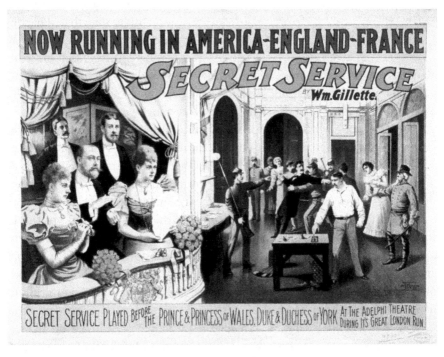

An 1897 poster for *Secret Service*. *Courtesy of Wikimedia Commons.*

William Gillette in *Secret Service. Courtesy of Wikimedia Commons.*

told to the audience that an observer of the proceedings in the scene might not learn. People move and talk as they do in real life."[41]

In 1976, when the play was revived in New York City and starred Meryl Streep and John Lithgow (the latter in the role Gillette originally played), *New York Times* critic Clive Barnes wrote it "was not Gillette's first attempt at a Civil War spy thriller, for nine years earlier he had written and staged the now forgotten 'Held by the Enemy.' But this time he got it right. Gorgeously right." Barnes went on to state that "Gillette has a certain sense of humor to his writing...but his real talent is for a kind of dramatic cliff-hanging that would make a mountain goat gasp....The old play rivets your attention from beginning to end—you are truly fascinated to discover what delicious absurdity is going to come next."

The success of *Secret Service* helped establish Gillette's place of preeminence on the American stage. It employed the realistic delivery of dialogue he had developed a fondness for as a boy and further demonstrated his technical talents, as well as his abilities as a playwright and actor. The production solidified his status as one of the biggest stars of the American stage.

Though the work was hailed for its literary merit, Gillette did not think the play or any play was a work of literature unto itself. Instead, he viewed a written play as merely instructions on how to perform the play. To come alive, the play's characters had to move from the page to the footlights, and for the spell to be completed, an audience was needed. "The admiration of a few librarians on account of certain arrangements of the words and phrases which it may contain can give it no value as drama," he wrote. "Such enthusiasm is not altogether unlike what a barber might feel over the exquisite way in which the hair has been arranged on a corpse; despite his approval it becomes quite necessary to bury it."[42]

The Actor and the Writer

As the dawn of the twentieth century approached, Doyle still held firm in his dislike of Holmes. In 1896, far from lamenting his actions, he wrote of Holmes: "I have had such an overdose of him that I feel towards him as I do towards pate de foie gras, of which I once ate too much, so that the name of it gives me a sickly feeling to this day."[43]

Over time, however, a need for money would do what mourning fans could not and change Doyle's hardline stance toward Holmes. Shortly after killing Holmes off, Doyle began overseeing the building of a splendid mansion called Undershaw in the village of Hindhead in Surrey, about forty miles southwest of London. As the project went over budget, Doyle's feelings about the consulting detective softened. In May 1897, he decided to revisit Holmes, though not quite in the way fans wanted. He remained steadfast in his reluctance to write a Holmes story, but he agreed to write a Holmes play, stressing that the play was not a resurrection and Holmes was still dead.

After completing his Sherlock Holmes play, Doyle approached several famous British actors with the part, among them Herbert Beerbohm Tree. Tree liked Doyle's play but wanted to make several bizarre changes to it in order to make the character better suited to his personality. These included playing Holmes with a beard and playing the roles of both Holmes and Moriarty, a wish made all the more difficult owing to the fact that Holmes and Moriarty appeared in several scenes together.

Rather than take action that he felt might hurt the character, Doyle toyed with scrapping the play altogether, which one gets the impression is what he truly wished to do. "I have grave doubts about putting Holmes on the stage at all—it is drawing attention to my weaker work which has unduly obscured my better—but rather than rewrite it on lines which would make a different Holmes from my Holmes, I would without the slightest pang put it back in the drawer. I daresay that will be the end of it, and probably the best one," he wrote.[44]

Holmes was in peril far greater than what he faced when he wrestled with Moriarty at Reichenbach Falls. Had Doyle given into his temptation to put this "lesser work" back in the drawer, then perhaps Holmes truly would have died at the falls. There would have been no deerstalker cap, no curved pipe, no "Elementary, my dear Watson" catchphrase, no *The Hound of the Baskervilles* and no Basil Rathbone, Robert Downey Jr. or Benedict Cumberbatch versions of Holmes. If Doyle had put the play in the drawer, it is possible Holmes's short-lived popularity would have faded over time into the dustbin of literary history.

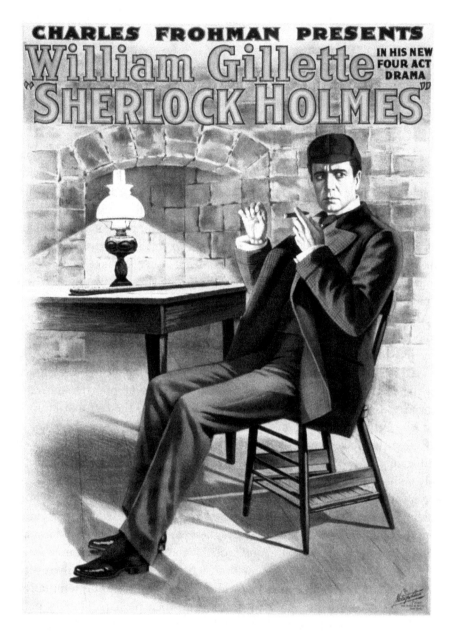

A lithograph of William Gillette as Sherlock Holmes, 1900. *Library of Congress Collection.*

Several of Doyle's other works have been forgotten over time. *The White Company* was a sprawling historic adventure novel that Doyle wrote in the 1890s. The work was painstakingly researched and followed a group of

archers in the Hundred Years' War. It is an impressive novel and one that was held in high esteem by Doyle himself. But despite its popularity up until World War II, it has largely been forgotten. Was Holmes destined for the same fate?

We'll never know. After Doyle failed to negotiate a deal with Tree, his literary agent put him in touch with the American producer Charles Frohman. Frohman was a successful producer with an eye for recognizing iconic characters. Frohman, who regularly worked with Gillette, had been behind such classics as 1889's *Shenandoah*, 1895's *The Shop Girl* and the New York premiere of *The Importance of Being Earnest*, by Oscar Wilde. It was also Frohman who produced J.M. Barrie's classic *Peter Pan* for its world premiere.

Frohman and Doyle immediately got along, and during their early discussions, he told Doyle he had the perfect actor in mind for the part of Sherlock Holmes: William Gillette.

When Gillette was offered the chance to play Holmes, he realized the potential of the character and felt audiences would be enthralled with the detective as well. However, he had some misgivings about Doyle's play and felt it needed significant revision.

As the process of rewriting the play got underway, Gillette asked for Doyle's blessing on some creative changes to the character, including giving him a love interest. He famously cabled the author with the question "May I marry Holmes?" to which Doyle responded, "You may marry or murder or do what you like with him."[45]

Doyle later admitted this was "a heartless reply," but Gillette was emboldened rather than daunted by it. More than a decade after his wife's untimely death, he had found a new suitor, and the resulting union between Gillette and Sherlock Holmes would be one of the most fruitful "marriages" in the history of both literature and the stage. While touring the country with *Secret Service*, Gillette—who had left Hartford as a young man in search of theatrical dreams and had already achieved more success than he could have reasonably hoped—began to write his magnum opus.

6

Holmes and Gillette

With Doyle's blessing secured, Gillette jumped into the writing of his Sherlock Holmes play with characteristic enthusiasm, completing it in just four weeks. He read all twenty-six Holmes stories in that time. Using the basic premise from a "A Scandal in Bohemia" as a template, he added the Holmes-Moriarty exchange from "The Final Problem." He also incorporated elements from "The Adventures of the Copper Beeches" and "A Study in Scarlet."

Loyal readers of Holmes plays would find plenty that was both new and familiar. Like Doyle's Holmes, Gillette's creation smoked, used cocaine, played the violin, could be arrogant in his displays of genius and was rife with eccentricity. But unlike the Holmes of the written word, Gillette's detective exhibited genuine human emotions—most notably his interest in members of the opposite sex. In perhaps his most controversial move, Gillette gave Holmes—a confirmed bachelor in the stories—a romantic subplot and even had the character falling in love. Some Sherlockians have taken issue with this decision, but the move likely increased Holmes's appeal, showing that despite his logic and mental strength, he had not outgrown all human weaknesses.

The closest thing Holmes had to a love interest in the book came from Irene Adler. Adler appears in "A Scandal in Bohemia," when the reader learns she has a compromising photo of one of Holmes's clients. She ultimately succeeds in outwitting the detective and is thereafter referred to simply as "the woman" by Holmes in a sign of his admiration for her.

William Gillette's study. *Courtesy of Connecticut's Department of Energy and Environmental Protection.*

In the play, Adler is replaced by Alice Faulkner. In addition, the nameless street urchin who sometimes helps Holmes in the stories gets a name: Billy, who at one point during the tour was played by a young Charlie Chaplin.

According to the lore surrounding Gillette, during rehearsals he replaced Holmes's straight pipe with a more distinctive curved one, possibly to better reveal his profile, or because it was less cumbersome for Gillette to hold in his mouth. Gillette also gave the character his large magnifying glass, replacing the small lens Holmes used in the stories, and his deerstalker cap, which had never been worn by Holmes in the stories although it had adorned the detective in the illustrations by Sidney Paget.

Equally as important as the cosmetic changes Gillette made to the character was the play's introduction of one of the immortal lines of popular culture. Though Holmes used the phrase "elementary" in passing in stories, it did not rise to the level of a catchphrase until Gillette's play included the lines "Oh, this is elementary, my dear fellow." This phrase later evolved into "Elementary, my dear Watson," one of the most instantly recognizable phrases in the English language.

Beyond these additions, Gillette also infused Holmes with a heavy dose of his own persona. In his biography of Gillette, Zecher wrote that the actor and playwright wrote the script in a manner designed to "accentuate his own acting skills." Doyle biographers agree with that assessment. Daniel Stashower wrote:

> In truth, Gillette's Sherlock Holmes had little more than a nodding acquaintance with Conan Doyle's creation. Though the play drew on elements of "A Scandal in Bohemia" and "The Final Problem," Gillette shrewdly tailored the character to suit his own talents. His Sherlock Holmes, in keeping with the demands of melodrama, emerged as a man who would keep his head when trapped in a gas chamber but could also play romantic scenes with the imperiled heroine, Miss Alice Faulkner. To this day, Holmes purists writhe in agony at Gillette's proclamation of love for his client: "Your powers of observation are somewhat remarkable, Miss Faulkner—and your deduction is quite correct! I suppose—indeed I know—that I love you."…Gillette became the embodiment of Sherlock Holmes for a generation of theatergoers.[46]

Martin Booth wrote that the marriage between Holmes and Gillette was a perfect one, recounting how when Doyle met Gillette, he "appeared just as he [Doyle] had always imagined Sherlock Holmes, were he real. The actor was exceedingly good-looking, tall, with sharp features and an air of authority about him. In addition, Gillette's character fitted the part. He was an eccentric, often reticent, coolly detached, sardonic and rational with a dry, mocking sense of humor."[47]

But the union of the English detective and American actor was not without incident. After completing the play in a feverish four weeks, Gillette left the manuscript at the Baldwin Hotel. In November 1898, the hotel caught fire at around 3:00 a.m. and burned to the ground in a blaze that killed at least two people. According to one tale, in the middle of the night, Gillette, who was staying at the nearby Palace Hotel, was woken up as the blaze still raged. "Is *this* hotel on fire?" he asked, annoyed. When told it was not, he remarked, "Well, come and tell me about it in the morning."[48]

Apparently from memory, Gillette was able to quickly rewrite the play, and hardly any time was lost as a result of the fire.

As the project took shape, Doyle became increasingly excited by the prospect of having the "famous American" play Holmes. In fact, the dollar signs began dancing in his eyes. "My agent says there are thousands of

pounds in it," he wrote to his mother, Mary Doyle, in January 1899. "So we are cheerful. But no chickens have been either hatched or counted. Only a couple of palpable eggs."[49]

That spring, Gillette traveled to England to meet with Doyle, show him the play and discuss final details. "Gillette is over with the Sherlock Holmes play which is I hope to make all our fortunes," Doyle wrote to Mary Doyle in May. "I hope to meet him tomorrow and get him down for the weekend."[50]

Meet him Doyle certainly did. After inviting Gillette to Undershaw, Doyle went to a nearby train station to pick him up. Stepping off the train was not an American actor but the detective Doyle had conjured with his pen. Gillette was in full Holmes regalia and cut a striking figure with his height and sharp features. Seeing Doyle, Gillette pulled out a magnifying glass and examined him for a few moments in seriousness before proclaiming, "Unquestionably an author!"[51] From that moment on, the two famous figures got along smashingly, and a successful collaboration was secured.

When the play was complete, what Gillette brought to the character was not lost on observers of the time. "This has been described as Conan

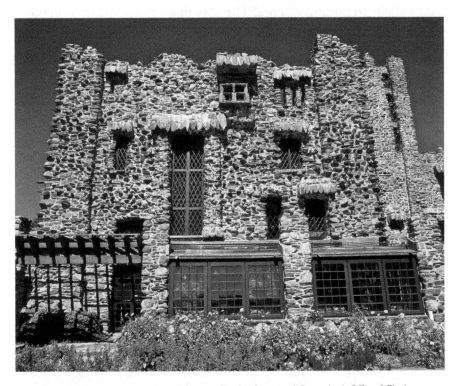

A modern-day look at the exterior of Gillette Castle. *Courtesy of Connecticut's Office of Tourism.*

Doyle's plot put on the stage by Gillette, but the fact is that it is all Gillette's work. The play is his and as truly as the playing."[52]

Though Doyle and Gillette shared the writing credit for the play, Doyle always gave full credit to Gillette. "The dramatization was done almost entirely by Mr. William Gillette," he told the *New York Times*. "He took my story and used it, as it seemed to him, to the best effect. I must say I think he was very successful. In fact, I have a very high opinion of his idea for situations, I do not know any actor who has this gift so highly developed."[53]

This positivity was expressed immediately after Doyle met with Gillette. In a letter the day after their momentous meeting, Doyle said he believed there was "a fortune" in the play and could not stem his enthusiasm. "Gillette has made a great play out of it, and he is a great actor, and bar some unforeseen event before October, when it will be produced in America, I am sure that it is destined for success, and if it once starts well it will go on running in many companies for many years. I am not usually over sanguine but I do have great hopes for this."[54]

Doyle was right in his assessment of Gillette's play and the American actor's ability to portray Holmes. The play that had sprung from the two men's imaginations and continent-spanning collaboration was destined for greatness. Ultimately, it would be more successful than either could have ever imagined.

With his curved pipe, precise manners, new catchphrase and newfound ability to experience emotions such as love, Holmes jumped onto the American stage with a powerful vengeance hardly matched before or since. Gillette would make the character so popular, so iconic, that it is hard to overstate. Years later, at a revival tour, Doyle would remark that Gillette had made it difficult for him to write about Holmes because he did not match up to Gillette's Holmes. "You make the poor hero of the anemic printed page a very limp object as compared with the glamour of your own personality which you infuse into his stage presentment."[55]

As Doyle had learned when Sherlock Holmes, not Gillette, stepped from the stagecoach that day near Undershaw, while he, the writer, may have created Holmes, William Gillette had become him.

7

Sherlock Holmes on the Stage

Following a copyright performance in England, *Sherlock Holmes* made its official American debut on October 23, 1899, at the Star Theatre in Buffalo. The theater had been built in 1888. The grand hall sat seven hundred guests on the first floor, five hundred on the balcony and another eight hundred in the gallery. There were also seven boxes with private staircases, and the theater was filled with ornate touches and an artistically treated brick exterior.

From the moment the curtain rose on the production, audiences were enraptured by this new incarnation of Holmes. The *Buffalo Express* wrote, "Considered by the unmeasured approval of which the large audience showered upon the venture, Sherlock Holmes must be placed in the long list of Mr. Gillette's successes. Certainly he scored a personal triumph as great as was his 'Held by the Enemy' and 'Secret Service.'" The *Buffalo Enquirer* said, "Its success was instantaneous. Curtain calls were the order of the evening. After each act the applause was so prolonged that it was necessary to raise the curtain two or three times. Even after the curtain had fallen on the last act, the audience continued its applause." The *Buffalo Evening News* wrote the play was "an instant and unmistakable success....There was a bit of a thrill when Mr. Gillette stepped on the stage, tall, thin, pale, holding himself well in hand....From that time on there was no question as to how the play would go. It proceeded with a dash and with an interest that held the audience silent intent on every word enjoying the more than clever acting."[56]

To be sure, the play was not without its detractors. Critic Sidney Sharpe wrote: "Sherlock Holmes, in spite of its almost certain property as a theatrical enterprise, is at bottom a rather disappointing, improbable and incomplete play—not to be compared for an instant with 'Secret Service' or 'Held by the Enemy,' two strong works of Gillette's own creation. It has no central action, properly speaking: its love story is sketchy and unimportant." Sharpe added that the reasoning with which Holmes solves his mysteries is "frequently so obscure as to appear wholly fanciful and unintelligible to an audience that has not been especially prepared in advance."

The *Tribune* went a step further, stating, "The play has no lasting value, of any kind whatever, unless it be the value of an occasional melodramatic incident," before adding, "stories of this kind are for the reader rather than the spectator. They lose their charm when they are taken from the field of the imagination and placed in that of the clear vision."

Those criticizing the play for its melodrama missed the point. The play was supposed to be melodramatic, supposed to appeal to the audience in the moment rather than their thoughts as they went home. Critic Clement Scott recognized what the play was going for and judged it positively on its own merits. But by doing so, he knew he would elicit sneers from his more jaded fellow New York critics:

> *I fear that the younger and more serious members of the critical bench will condemn me as a heretic....But all the same I cannot divorce myself from the fascination of my old and original sweetheart, melodrama. "Age cannot wither nor custom stale the infinite variety" of my electric emotions. In the theater I still love to be thrilled and I do not disdain what we call at home a "shilling shocker" in a cozy corner of a railway train. I cannot get on with the "new love" known as Miss Degenerate Drama, because I still see brightness in the eye and suppleness in the form of my dear "old love" Mrs. Playful Sensation.*

On the whole, Scott called the production "a most interesting and exciting evening, a dramatic triumph both as author and actor for William Gillette, who gave the most natural, self-contained and impressive performance I have ever seen in modern realistic drama. I only regret that Dr. Conan Doyle was not present to witness this emphatic success."

Another critic, Hillary Bell, praised Gillette's work in the production: "His portrait of the detective was a complete study of calmness, case and

philosophy, and his imperturbability in scenes of danger held the spectators in alternate suspense and applause."[57]

The praise of these critics and others, and the applause of audiences who saw it, drowned out the naysayers. Over the next thirty years, Gillette would portray Holmes more than 1,300 times, appearing on hundreds of stages on multiple continents before tens of thousands of audience members, among them celebrities, statesmen, kings and queens.

But before this success came to pass, Gillette and his *Sherlock Holmes* play faced one final challenge: taking Holmes home to England.

———•———

After touring in the United States with the production for more than a year, Gillette brought *Sherlock Holmes* to England, premiering the play at the Shakespeare Theatre in Liverpool on September 2. At that theater, like in America, audiences loved the play. In a speech after the performance, Gillette thanked the crowd for its warm reception with humbleness and his characteristically dry wit:

> *I am very pleased indeed by the heartiness of your applause, and also that there is so much of it, because it happens there are quite a number of us to divide it amongst, and it is very pleasant indeed to have plenty to go round. For that part of it which may be taken as an inclination of your approval of the play I wish to thank you most sincerely on behalf of Dr. Conan Doyle, who is unable to be present tonight, and who is the creator of that which I have endeavored to transfer to the stage with as little damage as possible. For that part of your applause which may be taken as indicating you are pleased, I thank you on behalf of the entire company. When all this has been taken away I feel sure there is a small bit at least left which I may consider as a welcome to England, for which I am deeply obliged to you.*[58]

A week later, when the play premiered at the Lyceum Theatre in London, the audience was less warm. Upset with what they saw as the encroachment of American theater owners and producers into London, fans had launched a booing campaign against American productions. Their ire was perhaps increased because Gillette, an American, was portraying a singularly English figure in Holmes.

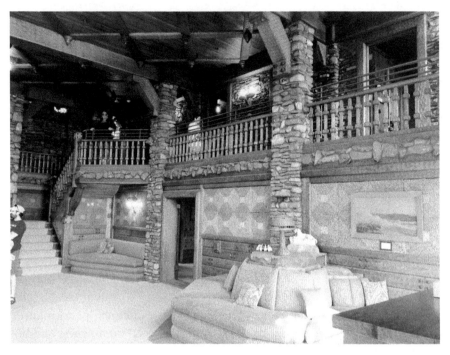

Gillette Castle's Great Hall in September 2015. *Photo by Corinne Ofgang.*

The *New York Times* reported that London newspapers "treat the subject conspicuously as a protest against American control of London theatres and the production in English-owned theatres of American plays. As one critic says, 'The "gods" were having their revenge upon American management.'" The *Echo* applauded the "dignified protests" because "it is not for the best interests of the stage that London should be inundated with American managers, playwrights and players."[59]

These theatergoers, though upset, were not booing the content of the production but merely the country in which the production had originated. Potentially more troubling were the criticisms of the play itself. One reviewer questioned whether Gillette and Doyle had made a mistake by bringing Holmes to the stage in any capacity. "Surely no playhouse is large enough to hold that colossal figure? You might as well attempt to get the Djinn into the bottle." The critic went on to state that seeing a flesh-and-blood Holmes on the stage

> *under the glare of the footlights, is to substitute intimacy for awe. These supremely great figures have a trick of being above dramatization....*

Print has the advantage of always leaving a margin for the imagination. Now Dr. Doyle and Mr. Gillette between them have cut away that margin. They give us our Sherlock not as he was, a composite photograph, a series of kaleidoscopic patterns, a splendid image. But a definite individual with a very rococo dressing-gown and a not very audible voice.[60]

As had been the case in America, the voice of these critics and the sound of the protesting boos were ultimately drowned out by approval for the production. By the end of September, the *Hartford Courant* reported, "In spite of the hostility shown to it on the first night William Gillette's play seems to have settled down into a distinct financial success. The Lyceum is filled nightly."[61]

By November, the *New York Times* announced that the play's London run had been extended through the next April. "Further evidence of the popularity of the play is found in the fact that four companies will start out in January to give it in the provinces. Companies are also rehearsing the piece for production in Antwerp, Vienna, and Hamburg. The Paris production will take place in February and the play will be given in Cape Town during the coming holidays."[62]

That December, the prince and princess of Wales attended a production of the play. After the first act, they summoned Gillette to the royal box and complimented him on his "artistic realization of Conan Doyle's famous character."[63]

History would side with admirers of the play, and it is clear that Gillette breathed new life into the character Doyle created. In so doing, Gillette helped secure the Baker Street detective's immortal legacy.

The success of the play had another effect on the evolution of Sherlock Holmes. Perhaps moved by the throngs of fans on both sides of the Atlantic who greeted the return of their once fallen hero Holmes, Doyle agreed once more to pen a Holmes story.

Between August 1901 and April 1902, Doyle published *The Hound of the Baskervilles*, one of the most popular novels in the Holmes canon and in English literature. It tells the tale of an apparently hellish hound that hunts a cursed country squire. It is set in Dartmoor, an area of moorland in the countryside of southern Devon in England, and has some of the most dramatic writing of any of the Holmes stories. Readers clamored for it.

For the Holmes faithful, there was a catch. Holmes had not officially been raised from the dead. This was a story from his casebook that

Watson had not yet recounted, and the action took place prior to the tragic events of "The Final Problem." So Holmes remained officially dead, but thanks in large part to Gillette, the detective was making a lot of noise from the grave.

THE CASTLE AND ITS CHARACTERS

8

Gillette's Houseboats

Early in the tour of *Sherlock Holmes*, a rumor started: Gillette would be retiring from the stage when the play's New England run came to an end. As a result, when the curtain fell on the final act of a performance in Boston, the crowd demanded a speech. Begrudgingly, Gillette gave in to this request:

Ladies and Gentleman—You are very kind indeed to express a desire to see me personally for a moment, and thus give me the opportunity of bidding you farewell. It is not, however, precisely the kind of farewell which you have possibly been led to expect. I am quite aware that some allusions have appeared in the papers to a probability that I would soon retire from the stage and go to work on a farm. You will be disappointed to learn that I don't intend to do this—unless the papers insist....One of the special blessings of modern civilization is the manner in which we—at least we of the theater—have our lives personally conducted, at no expense to ourselves, by the enterprising journalists of the day. Please do not understand me as complaining of this; I like it. It saves trouble and anxiety. We find ourselves sick and well—engaged to be married to people we don't know....We have trouble in the family—divorces are contemplated—we are robbed of jewelry, and fall desperately in love with other people's wives and husbands and this without having the trouble of going through it at all—unless we prefer to do so....When I pick up a paper in the morning and find that I am very ill again I do not worry about it and call in doctors and nurses, but

*sit around quietly and let the papers pull me through. I watch the morning
editions carefully to see how I am getting on, and as soon as they have me
out of danger I try to get about again and attend to business as usual.*

On a slightly more serious note, Gillette went on to explain that he
had no intention of retiring and hoped to appear again in Boston but not
necessarily in front of the curtain as he was at the moment because "an
actor should not allow himself to be drawn before the curtain, no matter
how flattering the inducement, for when he does, he destroys the illusion
which he and his fellow actors have been striving to create and upon which
so much of the success of the modern drama depends."[64]

Far from retiring from the stage, Gillette would continue to portray
Holmes and other characters for years. Thanks in large part to his
portrayal of Holmes, he had become the highest-earning actor of the
day. Offstage and out of character, he began to retreat further and further
from the spotlight, guarding his personal life with the same zeal as always,
but he chose to spend his money in delightfully attractive ways that drew
increasing attention from the media. His penchant for outlandish living
would culminate in the construction of Gillette Castle, but the signs of his
interest in unusual homes were evident much earlier in his life.

In the 1890s, he became fascinated with houseboats, purchasing his
first, which he christened the *Holy Terror*, in 1896. Lumbering and slow-
moving, the boat prowled the waters of the Hudson and Connecticut
Rivers with Gillette on board and leisure, not speed, as its goal. In July of
that year, the *Brooklyn Eagle* proclaimed it one of "the queerest specimens
of a yacht seen in the waters for many a day" and added, "Mr. Gillette is
not much of a yachtsman, but his conception of the comfortable is above
par as plainly shown in the construction of this boat."[65]

Gillette seemed genuinely confused that others did not understand the
appeal of his sixty-two-foot-long, lumbering craft. In an article about
houseboats in 1900, Gillette chided Americans for their criticism of the
practice:

*It does not suit our ideas of competitive amusement. If we have a yacht, it
must be a cup-winner, and be ever on the lookout for a skirmish. The idea
of snailing up the beautiful Hudson with the jolliest of company, with song
and dance and chatter and books, the least of the river-craft easily passing
us, seems a reflection on our progressive spirit. If it be a horse, it must be
daily on the speedway looking out for a "brush," and if there is a hundred*

The Castle and Its Characters

William Gillette's houseboat the *Aunt Polly*. *Courtesy of Connecticut's Department of Energy and Environmental Protection.*

> *dollars on one side so much the jollier. Americans are all right when they are chained to something stationary; they can assume a virtue of repose even if they have it not; but when they are aboard anything that moves, it must move at a swifter pace than any of its competitors.*

Gillette then described how, after taking friends on his houseboat, many guests grew bored after an hour or so:

> *The fact that almost any tug could have made rings around us all the way up the course seemed a sort of reflection on their progressiveness. They were polite and congratulatory but visibly bored. One by one the truants slipped a bank-note into the pilot's hands, and, with the boat swinging skillfully up near this dock and that, the renegades hopped ashore, tipping their hats with somewhat the same apology, "awfully sorry, old chap, but that's too confounded slow for me!" and started for Long Branch, Newport, Saratoga, or the Adirondacks where they could take their recreations as violently as suited their spirit of touch and go.*

The actor was undismayed by this reaction to his hobby, proclaiming the pastime perfect for someone with a busy life. "To one who lives at a great strain the rest of the year, a summer spent on a houseboat is just the kind of sport that best recuperates the nervous energy, and prepares well for the coming campaign."[66]

Following his success portraying Holmes, Gillette purchased a new houseboat to replace the *Holy Terror*. Built in Brooklyn, New York, this new houseboat was launched in 1900. The following year, Gillette had the boat remodeled, and the completed craft was an aquatic palace of comfort he called the *Aunt Polly*. It was 144 feet long, just over 18 feet wide and weighed two hundred tons. The main cabin was 40 feet long, replete with 8-foot-high ceilings. In addition, there were four staterooms, a dining room, a fireplace, a library, a bar and a piano. Large windows along the craft's sides provided expansive views of the water, and there were many places to sit back and relax, including large easy rockers and plush sofa pillows. Turkish rugs completed the effect of a floating palace.

Operating the mighty vessel required eight men, and like Gillette's previous houseboat, it rarely failed to capture the attention of the press. In September 1900, the *Hartford Courant* reported the boat's arrival on the Connecticut River flying the flag of the Hartford Yacht Club. "The boat attracted much attention as she passed the Fenwick station of the club and all the way up to Hartford. She is an unusual craft for these waters."[67] The *New York Times* and other major publications reported on the vessel's comings and goings, marveling at the comforts of the vessel.

According to press reports of the day, J.M. Barrie, the Scottish novelist and playwright who gave the world Peter Pan, was so intrigued by stories of the boat that he made a special trip to America just to spend some time with Gillette on it. (Gillette and Barrie were friends and shared a producer, Charles Frohman.)

Despite its elaborate comforts, the vessel was famously lacking when it came to speed. Gillette said it was propelled by a sewing machine motor and relished recounting tales of the ship's snail pace. He said in "fair tide and fair wind, it could make two and one-quarter miles an hour but without this assistance it was likely to go in either direction." He added, "He could always think of a destination in the direction the boat chose to go." On his first trip up the Connecticut River, while visiting from New York, he whistled for the drawbridge in Old Saybrook but the bridge opened and closed two or three times while waiting for his boat. When Gillette and the *Aunt Polly* finally passed through, the bridge attendant stuck his head out and asked when he had left New York. After Gillette replied "July 3," which was only a few days earlier, the attendant asked, "What year?"[68]

It is curious that Gillette, a notoriously press-shy celebrity off the stage, would seek out a leisure activity so outlandish it could not fail to draw the

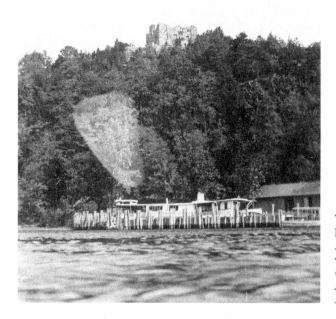

William Gillette's houseboat the *Aunt Polly*, docked at the river with the castle above. *Courtesy of Connecticut's Department of Energy and Environmental Protection.*

attention of the press. It was paradoxical behavior he would repeat with his most famous creation outside of the theater, Gillette Castle.

The similarities between Gillette Castle and Gillette's two houseboats don't end there. Like the castle, the lumbering houseboats were examples of form over function, and not just any form—an eccentric style and flair that encapsulated Gillette's singular personality.

One can also see design elements in the *Aunt Polly* that would later be replicated in the castle. For instance, the houseboat had furniture built into the boat itself, a practice Gillette would duplicate at the castle, where many pieces of furniture are part of the physical structure of the house. The houseboats also demonstrated Gillette's love of the water, and it is no coincidence that his castle overlooks the Connecticut River.

Finally, his second houseboat would become a part of the creation lore of Gillette Castle. According to a frequently repeated history of the castle, it was while sailing on the houseboat that Gillette first saw the property the castle sits on and decided to make it the spot of his future dwelling. But this tale, though it is repeated again and again, is, like so much that is written about the life of Gillette, merely a myth.

The Castle Takes Shape

I n 1913, so the story goes, Gillette was sailing the Connecticut River on the *Aunt Polly* when he first took serious note of the Seven Sisters, a collection of seven rolling hills overlooking a quiet corner of the Connecticut River. These hills hugging the river enchanted him, and he moored his boat before climbing to the top of the highest peak. Looking out across the valley and the river he had so often traversed in the *Aunt Polly*, he decided in that instant he would purchase the property and build a country home and retreat like no other.

It is a powerful story of discovery. Standing on the tallest of the Seven Sisters, one can see why it rang true; after all, who wouldn't be enchanted by the view of the river valley below with the tranquility of the water only occasionally broken by the peaceful, plodding passage of the Chester-Hadlyme Ferry, which runs today and ran in 1913. However, the story is not true.

While attempting to verify the dates, Alan Levere, a historian with Connecticut's state park system, discovered the property was registered to Gillette long before 1913. But although the dates are clearly off, there may be a kernel of truth in the tale of the *Aunt Polly* aiding the discovery of the castle site.

A 1921 *Hartford Courant* story on the castle quotes one of the structure's builders, named Frank Preston, explaining that Gillette had "been planning on the house for a great many years [and] sketched the plans himself roughly." Preston added in the interview, "I don't know why he chose this place, except

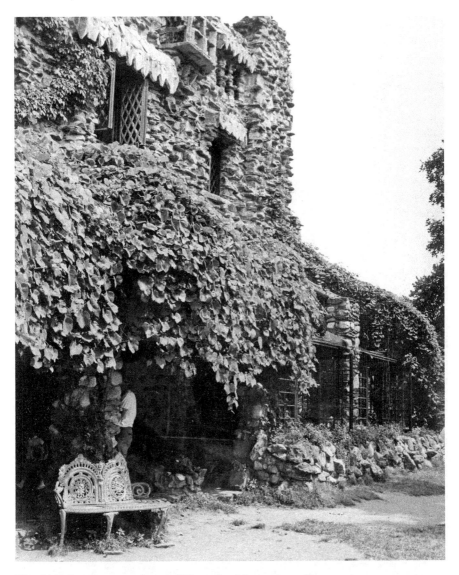

The thick vines that once clung to Gillette Castle's exterior walls are no longer present on the site today. *Courtesy of Connecticut's Department of Energy and Environmental Protection.*

that he anchored off here in the *Aunt Polly*, climbed the hill here and liked the view I guess."[69]

Gillette said he was first interested in the castle as a summer camp, a place he could dock the *Aunt Polly* during the warmer months, but over time, his plan for the property grew more ambitious. By 1914, he had begun building the home that would one day bear his name. He acquired

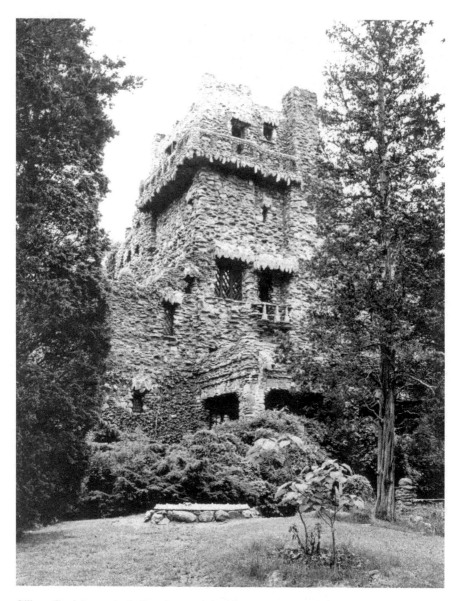

Gillette Castle's exterior before the vegetation that once surrounded the building was cleared by the State of Connecticut. *Courtesy of Connecticut's Department of Energy and Environmental Protection.*

additional land over the years that would ultimately total 122 acres, and today the state-run Gillette Castle Park has 190 acres. He built a dock for the *Aunt Polly* and would periodically supervise construction of the castle, living in his houseboat at the base of the castle as he did.

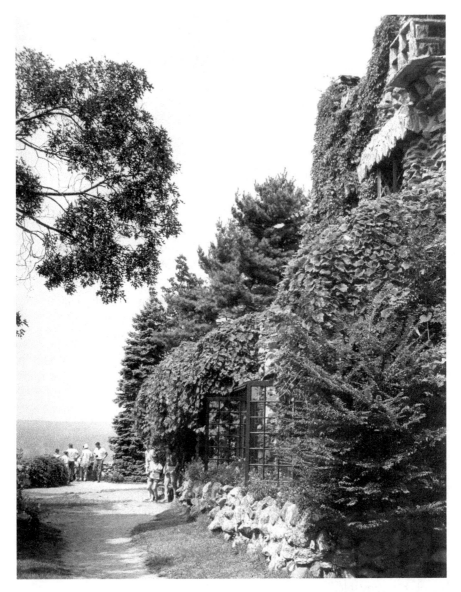

Guests explore the grounds of Gillette Castle shortly after it was opened as a state park. *Courtesy of Connecticut's Department of Energy and Environmental Protection.*

With the home, Gillette would take his place among the theatrical luminaires of his day. As Richard Schickel noted, "Among the great actor-managers the tradition of owning an imposing country estate, a sequestered retreat from the rigors of the road, was a powerful signal of status. Junuis Brutus Booth had his Arcadia farm near Baltimore. James O'Neill had his

seaside retreat in New London....William Gillette had his eccentric's castle in Connecticut in which to rest from his labors as Sherlock Holmes. Real estate of this character was as much a part of theatrical success...as an orotund vocal manner or the sweeping gesture with a cape."[70]

While many successful people from acting and other professions have built grandiose estates, Gillette's country retreat was and is different. Built from the wildness of his imagination, the home that would spring up over the next five years and tower above the Connecticut River would defy categories and, in some cases, logic. The *Washington Post* called it the "acme of [Gillette's] dreams," describing it "as something of a rhapsody in harmony" and adding that it was "created by the agile mind of someone who enjoyed off-beat harmonies."[71]

In his work on American mansions, Merrill Folsom described the dwelling as the summary of the "success upon which all [Gillette's] dreams were built" and a "small boy's dream of paradise."[72]

Gillette bristled at the notion that he was building a castle, calling the structure his "Hadlyme Stone Heap" instead. But call it what he would, Gillette could not help but draw attention with his new home. Even before the castle was completed, the mystery and interest surrounding it was intense.

The castle was primarily designed by Gillette and was built with local fieldstone supported by a steel framework. The majority of the work took twenty men five years to complete, from 1914 to 1919. After the main structure was completed, Gillette would supervise thousands of refinements created by local craftsmen.

The remoteness of the site gave workers pause. Preston told the *Courant* that when he first visited, "before the work was started[,] I looked at the hill, climbed to the top, looked around and below, I sat down on a stump and said to myself—how in the world is anyone going to build a house up there? It looked impossible."

Preston was not the only worker who had trepidations. One of the men working under him looked at the building lot and said, "Not for me." Preston recounted, "He left us and enlisted in the army, preferring to face the Germans rather than help to build a house up here."[73]

As the *Hartford Courant* reported, "The Foundations for [the] home were located two hundred feet above the river. Stone that would have made a pyramid builder wild with envy and building sand of the best

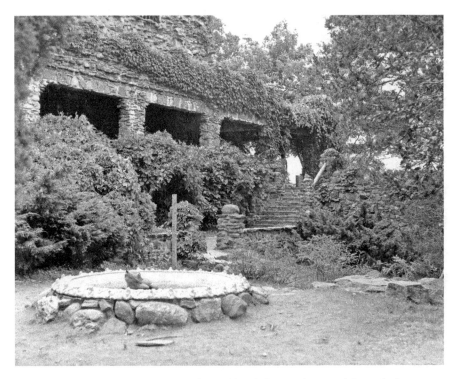

A frog pond at Gillette Castle is shown in this historic image. *Courtesy of Connecticut's Department of Energy and Environmental Protection.*

quality were at hand in reckless profusion. But to build the type of home that Mr. Gillette had in mind, that would neither rock nor fall when the winds came up and the rain descended, cement, lumber and iron were necessary."[74]

The property was a half mile away from the nearest railroad station, and many of the materials had to be slogged from the river up the hill.

One of the most difficult parts was to build a roadway to the top. In order to do this, builders had to blast some rocks and build small bridges over others. Many rocks used for the building were taken from the property itself where they were plastered into one structure.

Once the materials were gathered, Preston said it was "like building any house."

This may have been something of an understatement. More than eight decades later, in the early 2000s, the State of Connecticut commissioned a renovation of the castle. In the process, much of the castle's classic elements were restored, and some modern amenities were added, including an exit staircase and updated sprinklers and heating systems. David H. Barkin, an

Gillette Castle's entrance. *Courtesy of Connecticut's Department of Energy and Environmental Protection.*

architect and president of Barkin Andrade Architects of New Haven, which restored the castle, told the *New York Times*, "There's nothing typical about this building. Everything about it is unique."

When workers replaced the old insulation, they found it was made of seaweed and paper, one factor that led Barkin to describe the architectural style of the castle as "a weird blending of Victorian and Arts and Crafts. There's a lot of strange stuff going on here."[75]

The strangeness of the place was apparent from the very beginning. As the castle took shape above the river, rumors began to swirl around the quiet town. "Is Gillette Building Castle on the Connecticut River?" asked one *Hartford Courant* headline, followed by the cryptic subheading: "Famous Actor Swears Grim Bulk of Stone Rising Above Sleepy Hadlyme Will Be a Regular House When It Is Completed, but Structure Has Its Mystery, Nevertheless."

On the nearby valley railroad, questions were constantly in the air. "Is he fixing it all up so he can go up there and bury himself here just before he dies?" a reporter overheard one imaginative child ask.

William Gillette at his Seventh Sister estate with one of his many cats. *Courtesy of Connecticut's Department of Energy and Environmental Protection.*

That same reporter, an unidentified journalist from the *Hartford Courant*, decided to visit the castle and find out what was going on in October 1918. "It was a sharp foggy morning," he reported. "The 'Aunt Polly' lay in the river, moored not far from the Hadlyme bank. Mr. Gillette was supposedly stretched at ease upon her when the stranger visited the sleepy little place."

When Gillette saw the journalist approaching his boat, he greeted him cordially. "Pleasant day, what are you roaming around for?" Gillette asked. The reporter responded, "People are so curious about what you are doing here, I thought I'd come down and look over what they call your 'castle,' and tell them whether or not the place was in shape for the winter."

At the word "castle," Gillette flinched before responding. "Castle. Why this isn't a castle; never was, and never will be. And I do wish that people would not burden me with this 'castle' idea."

The reporter wouldn't let it go. "But you like castles don't you, Mr. Gillette?" he persisted, pointing out that it looked like a castle from the river. Gillette replied, "I never was in a 'castle.' Castles? Why I always got as far away from them as I could. I hate 'castles!'....If people are interested in me and what I am doing—although why my putting up a house here should bother any one but me I can't see—just take a picture from the other side of the river and tell them that my home is not done yet, but it and I are doing nicely."

Gillette then implored the newspaperman to put an end to the castle rumors. "Abolish this 'castle' idea for me, please do," he said. "Say that I am building a home. It is uncompleted, an unfinished house of stone. I had

planned to start it before we entered the war. My home for years has been for months of the year on wheels. I wanted a permanent place for a home. Starting with the idea of a mere lodge or camp, I got some rough stone, told them to mix red mortar with it—and here you see it."[76]

As usual, Gillette's words did little to illuminate. However, as with his acting and his plays, the work itself—in this case the castle—speaks for itself. Far from an accident of "stone" mixed haphazardly with "red mortar," the castle and its grounds are a fantasy come to life. Its stone exterior is a nod to the past, but its thoroughly modern interior is a nod toward progress and the future. The castle was one of the first in the region to have electricity, and it would light up the night sky above the river. It was outfitted with sliding furniture and other gimmicks that imitated the ingenuity of stage technology but also served as precursors to the automated home visions of the future that rose to popularity in the 1950s.

The kaleidoscopic assortment of gadgets, hidden doorways, stone and steel that was slowly taking shape above the Connecticut River in 1918 was not a pile of rocks as its creator wanted the public to believe; it was most certainly a castle.

10

Inside the Castle

In the winter of 1921, with the exterior of Gillette Castle recently completed, a group of reporters from the *Hartford Courant* set out to see the spot for themselves. Aware of "Gillette's reputation of maintaining the silence of the Sphinx," the group sought not to interview him but to "interview the castle," learning what they could about the structure from the building itself. Gillette was not home during their visit, and much of the structure was still being completed and tweaked. Even still, they found the castle lived up to the hype surrounding it. Seeing the structure for the first time from across the river, they described a fairy-tale scene, with the castle's "angular walls scraping the sky, its rocky base grown over with thick foliage, covered with winding paths, rustic bridges overhanging the water for many feet, secret nooks, and at the very bottom a private boat dock and boat, *Aunt Polly*."

Later, after peering inside the Great Hall, the authors of the story would proclaim in the third person, "It was unlike any house they had ever seen. Half way up the sides of the walls and extending apparently half way around the room was a sort of balcony. This opened into a number of rooms. Directly across was an immense fireplace, which was built of stone."[77]

The woodwork within the castle is hand-hewn southern white oak. Gillette insisted that the materials he used be kept in their natural state without polish or paint. Approximately fourteen thousand square feet in all, the castle has twenty-four rooms. Once Gillette was done tinkering with its interior, it would boast built-in couches, a heated bed, an early fire-suppression system, a movable table on tracks, light switches made of carved wood and forty-seven

The large wooden switches that control many of the lights at Gillette Castle. *Photo by Magnus Bäck via Wikimedia Commons.*

carved doors, each more intricate than the last. Some of the light switches in the house are modeled after old-fashioned stage switches; others resemble steam locomotive levers. The fieldstone walls are five feet thick at their base and two feet thick at the top.

The house Gillette created had as much inherent drama as any of his plays. There are secret rooms and passageways, spy mirrors and gimmicked furniture; each room has its secrets and its story to tell.

Guests would enter the castle through a porte-cochère, a covered carriage entrance. Gillette had a hidden passage to the darkly lit entrance room, so after a servant let his guests in, he could appear suddenly and surprise them.

From the entrance, guests make their way to the living room or Great Hall that is the centerpiece of the castle. With a feel that is far more country lodge than palace ballroom, this Great Hall stops guests in their tracks. The wood-paneled ceiling two stories above is held by stone pillars, comfortable-looking couches dot the walls and a balcony overlooks it all, wrapping around two walls. The large fireplace that the *Hartford Courant* reporters witnessed in 1921 still dominates one wall. The room conveys, simultaneously, a hobbit-like sense of comfort and dramatic stage-worthy sense of grandeur and drama. Gillette often held court in the great room, and a series of methodically placed mirrors let him spy on various areas

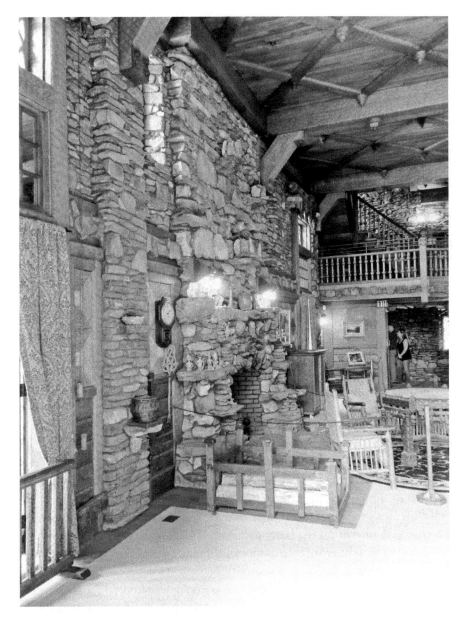

The giant stone fireplace that dominates the Great Hall at Gillette Castle. *Photo by Corinne Ofgang.*

in the great room while remaining unseen upstairs. He would use these mirrors to great effect, pranking his guests and surprising them with well-timed appearances.

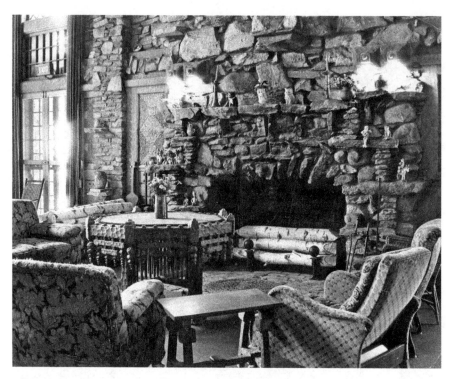

The hearth within the Great Hall of Gillette Castle. *Courtesy of Connecticut's Department of Energy and Environmental Protection.*

Near the living room was a well-stocked cocktail bar with characteristically eccentric design. The cabinet-like wooden bar had a cover that could only be unlocked by applying pressure on a certain spot in the back of the bar. Some have theorized incorrectly that this closed bar was designed during Prohibition to hide alcohol from authorities. In reality, it is a "trick bar" and provided another way for Gillette to prank his guests. A mirror on the balcony allowed Gillette to see the bar, and he delighted in watching his guests attempt in vain to open it before strolling down and casually opening it himself.

Off the Great Hall is a conservatory where sunlight pours in through paneled glasses. A waterfall cascades down into a pool where Gillette once kept goldfish and two frogs named Mike and Lena. Gillette's many cats ensured these frogs did not enjoy long lives, but every time one of the cats made a meal of the frogs, Gillette would replace them with a new frog with the same name.

The dining room is also close to the living room. The room is long and narrow; guests were seated on a cushioned seat that ran along the wall. When they were situated, the table would be pulled to them on rollers and

The gimmicked bar at Gillette Castle. *Courtesy of Connecticut's Department of Energy and Environmental Protection.*

then locked into place. Gillette generally sat in the middle of the bench, where he could signal his servants by means of a floorboard with a buzzer electronically connected to the pantry.

Also on the first floor is Gillette's private study. The chair in front of the desk sits on rollers that allowed Gillette to roll away from the desk. Behind

the desk is a safe and a trick door through which Gillette could escape from unwanted guests. The trick door leads to Gillette's workshop, where he tinkered with designs for the house and did other woodwork.

The upstairs floors are equally as impressive. There is a library with works ranging from his father Francis's old collections to his own extensive collection of works by William Shakespeare, Jack London, Robert Louis Stevenson and many others. Large planks of wood could be locked over the books on the shelves to keep them from blowing over during storms. It was a stylistic element borrowed from the *Aunt Polly*, where the planks were a necessity to keep the books in place during water voyages. Today, these planks are used to lock up rare books still kept at the castle.

Given the grandeur of the house, Gillette's master bedroom is relatively small. It has a dresser built into the wall and allowed Gillette quick access to various points in the house, and the spy mirrors allowed Gillette to view much of what was going in the rest of the house from the bedroom.

There are relatively plain metal beds throughout the house, chosen, according to some accounts, because they were easier to clean and less subject to the bugs Gillette had endured in so many hotels while touring. There is also an art gallery that originally contained more than one hundred paintings. Gillette was particularly fond of landscapes and seascapes. His art collection was not very valuable and was based more on what he personally enjoyed than on expensive collector's items.

Above the library is a tower room. Currently closed to guests of the castle, the tower bedroom provides a panoramic view of the valley spanning north to Hartford and south to Long Island. The roof held a water tank with 3,800 gallons of water in it that was linked to additional reserve tanks. A pulley on the second floor would release this water in the event of a fire.

Also inaccessible to guests today is the so-called secret room. This room is a second tower room only accessible through a trapdoor found above a servant's staircase. To get to this room, a foldout ladder pulls down over the staircase. According to Zecher, Gillette would do much of his writing in the room and the children of guests would stay there, but getting to the room by means of the trapdoor-and-ladder system is difficult and appears to many modern observers a strange design element. So there remains mystery surrounding what Gillette's motives were in building the room.

Often, those who visited the castle could not help but be reminded of Holmes. "He now came down a balcony stairway into his living room," recalled one castle guest. "He descended silently. He was calm, dignified, erect and commanding. He wore black, with a gold watch chain looped across his waistcoat. He spoke and he spoke genially, but his voice was crisp, crackling, shrill. I felt then, as did his other guests before that great stone fireplace, that Mr. Holmes of Baker Street had somehow slipped into the tremendous stone house. All of us were strangely awed by his presence."[78]

Indeed, the presence of Gillette and his even more famous alter ego pervaded the home, which had been designed with the whim of its king in mind. "It was a happy household perfectly geared to the wishes and habits of its master," wrote Fred Van Name in the 1950s in a history of the castle prepared for the state park system. "To his faithful servants, the clock moved not with the sun but in accordance with his mode of living. In years of trouping, William Gillette had accustomed himself to late hours, thus altering what might be considered normal routine. At the castle, breakfast usually was at eleven every morning, luncheon at three-thirty in the afternoon and dinner promptly at eight; mealtimes were rarely changed to suit the convenience of guests. Thus, there were prescribed hours for sleeping, eating, for recreation and for writing."[79]

Despite being the undisputed master of his castle, Gillette was by all accounts kind and considerate to those in his employ and did not lord over other residents in the valley, often inviting those who worked on the building and "their families and local residents to small teas at the castle, which remained as lively and as spirited as the lord of the manor."[80]

The tales of visitors enchanted by the castle are many. The poet Ruth Guthrie Harding and her husband, Richard Burton, also a poet, spent a great deal of time at the castle. Harding recalls their time there as idyllic. "There were logs blazing in the huge fireplace and the lights were turned down, and we would spend hours after dinner in marvelous reminiscence. William and Richard spoke the gay 'Do you remember?'...It seemed sometimes that the laughter in that room must be heard in the valley below."[81]

But not every visitor over the years has been enchanted by the castle's spell.

"The castle is an architectural folly built in 1917 [*sic*] by William Gillette," wrote William Grimes for the *New York Times* in 1992.

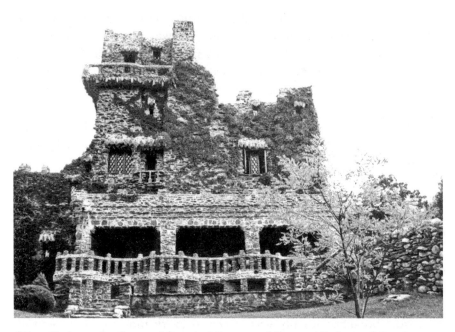

Gillette Castle exterior. *Courtesy of Connecticut's Department of Energy and Environmental Protection.*

The house is ugly beyond description, a monstrosity of rough-hewn
stone that suggests an ungifted child's papier-mâché classroom project
on the Crusades. It is so repellent that it commands a certain respect.
The interior, a riot of exaggerated textures and unbridled rustication,
falls somewhere between a Bavarian hunting lodge and the house in
"The Rocky Horror Picture Show." Ceramic frog troubadours sit on
the massive fireplace mantel. At one time, Gillette amused his guests
with a miniature railroad that ran around the grounds. Today, only the
stations remain. The view overlooking the river remains intact. This,
Gillette could not alter.[82]

This criticism, like many of the criticisms of Gillette's plays, missed the
point. Gillette Castle is intentionally absurd and designed to be a crowd
pleaser. This was Gillette's greatest strength as an actor and playwright,
and it was also his greatest strength as an amateur architect.

In 1921, on that cold winter's afternoon, that group of reporters
from the *Hartford Courant* understood the spirit of the castle. Leaving the
grounds of the property, they saw the structure in the fading light and
were moved. "The 'castle' outlines could be seen against the light of the

sinking sun. The sky was alight over the horizon with its bright hue of pink, checked here and there with a string of gray cloud. The scene was entirely unlike any familiar to the Connecticut hills."[83]

And they hadn't even seen what would become the most prominent feature of the castle's exterior: the railroad.

11

The Train

The 1927 newsreel shows William Gillette at age seventy-two dressed as a train conductor, hat and all, standing astride a steam engine. Speaking with fast, enthusiastic diction reminiscent of an early radioman, Gillette espouses his passion for trains. "Ever since I was an infant and for all I know before, I've had the idea that I'd like to drive a locomotive," he says. "People didn't tell me that I was born with a silver spoon in my mouth, but I've often heard that I was born with a steam engine in my mouth. And at last I've got one. I had to build one so as to drive it—it's a long while since I've heard—but now I've got my wish at last."

With that, Gillette invites the viewer to take a ride on the train with him. On the newsreel, the steam from the locomotive can be seen rising against the Connecticut trees; the cry of its whistle fills the air, mixing with the rhythmic *chug, chug, chug* of the steam engine's wheels and the *clattertrap* of the train moving over the tracks. We see three large open-air cars being pulled by the locomotive across trestle bridges and through a tunnel.[84]

This train was arguably the crown jewel of the castle. For Gillette's prized miniature steam engine, he had laid three miles of nearly eighteen-inch-gauge track. There was a seventy-five-foot-long tunnel; several bridges, some of which curved perilously over rocky outcroppings towering above the river; a roundhouse; and Grand Central Station, which served as a stone terminal for the steam engine.

Gillette admitted the train was "merely a plaything" but one that he built at considerable expense to fulfill his "unsatisfied boyhood ambition" of being a "railroad man."[85]

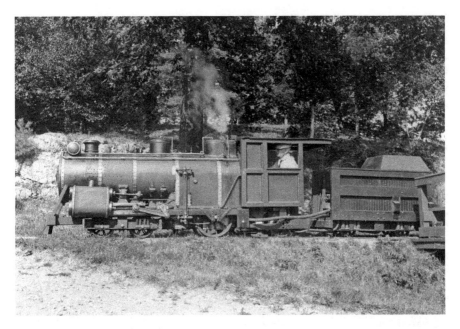

Gillette driving his steam engine. *Courtesy of Connecticut's Department of Energy and Environmental Protection.*

A writer from *Popular Mechanics* visited the estate and rode the train in 1931. "From the train, the passenger gains a view of most of the estate during a round trip over the system," the writer reported, adding that Gillette "built his cars without tops, to make them better for sightseeing."[86]

Riding it was a rite of passage for castle guests, who would be sped across the estate property on the rickety train track, which Gillette named the Seventh Sister Short-Line Railroad. Among those who rode the railway were Helen Hayes, the "First Lady of American Theatre," and one of twelve people to have won an Emmy, a Grammy, an Oscar and a Tony Award; former president Calvin Coolidge Jr.; and theoretical physicist Albert Einstein.

Unlike on his houseboat, where Gillette was dedicated to a slow and peaceful journey, as the engineer of his railroad, he pushed for speed, shooting around the tracks at a pace that sometimes made his guests uncomfortable. According to a joke still told by castle staff on the grounds of the property today, it was the harrowing trip on the Seventh Sister Short-Line Railroad that caused Einstein's hair to stand on end.

The railroad was only one of the many impressive structures dotting the castle grounds. There was a service station for the railroad, a three-

Grand Central Station, once the terminal for Gillette's railroad line, was transformed to a picnic area after the state acquired the castle. *Courtesy of Connecticut's Department of Energy and Environmental Protection.*

car garage, a horse barn, a three-story house with a tool house and carpenter's shop, a gardener's cottage and, in the woods, a log-cabin playhouse for children.

Evergreen trees and shrubs used to dot the exterior of the castle, but these were cleared after the state obtained the property. Sadly, many of the exterior structures once found on the castle grounds are no longer present, most notably the railway line.

In the 1940s, after the state acquired the castle, most of the tracks were removed. The train car and the locomotive were sold to Lake Compounce. The area where the roundhouse that housed the cars of Gillette's train once stood is now occupied by the castle's large visitor center, built in 2002. Inside the center, guests can find one of the two locomotives Gillette used to power his train. Though you can't ride it, the locomotive was beautifully restored in 2007. Viewing it, one gets the sense of the craftsmanship Gillette employed for his "plaything." No real-world, full-size locomotive could be more striking in appearance.

Gillette Castle's grounds. The evergreens and vines once found around the castle were removed after the state acquired the property. *Courtesy of Connecticut's Department of Energy and Environmental Protection.*

The Grand Central Terminal, where guests often began and ended their ride on the track, still stands in front of the castle. It is a stone canopy that matches the architecture of the castle itself and provides shade from the sun for guests visiting in the summer. Though the railroad is no more,

visitors can travel most of its path on foot by what is known today as the Railroad Trail. The approximately three-mile trail allows one to explore many remnants of the old railway. At different points, the railroad's original bed, lined by fieldstone or bordered by stone walls, is visible. The wooden trestles, some spanning as far as forty feet, can be crossed, and guests who don't mind dark space can walk through the seventy-five-foot-long cavern.

Beyond the sound of the train, visitors to the castle in Gillette's day would find many animals. Chief among them were Gillette's cats. At one point the castle was home to as many as seventeen felines. Gillette admired cats for their intelligence and aloofness, and his love of them was a lifelong one. While touring as an actor, he would seek out the house cat at each theater he would attend, bringing the feline milk and food. There were also cats on the *Aunt Polly*, and in addition to real-life cats, the castle was filled with many sculptures of cats and other tributes to the felines. As Zecher wrote:

> *His cats had the run of the castle, with a special tiny built-in door through which they could go in and out at will. They were even permitted to enter the conservatory with its fountain and brook to gaze longingly at the fish swimming in the water or the frogs hopping about the rocks. A newspaper reporter once counted no fewer than seventy-seven cats of one form or another: ceramic cats, pictures, doorsteps shaped like cats and at one time seventeen live ones. Gillette considered it a compliment to his guests when the cats took to them.[87]*

The castle even had a bell that the cook could use to ring the cats to their meals, which they would often eat at the table with Gillette. Predictably, because of all the cats he owned, Gillette sometimes had unwanted kittens. As a result, he once ran an unusual advertisement in a local paper:

> *Two perfectly black Tommy Kittens to be given away. Both have double fore of a family of great mousers. Anyone wanting one or both of these delightful felines, must write stating qualifications—that is, we want to be sure that they do not go to stupid boobs who do not know what a cat is. Would like to have recommendation from last cats you have lived with, but probably that is asking too much.[88]*

Once, after the critic and scholar William Lyons Phelps wrote an article about cats, Gillette sent him a note espousing three important additional feline qualities:

1. *"The absolute necessity of cats for the preservation of birds." The more birds that cats killed, the millions more "whose lives were spared by the destruction of their enemies."*
2. *The fact that cats possess an extra "sense," that is to say, they are either mind-readers or else capable of reading the reactions of humans in some other sort of mental process.*
3. *He forgot what the third point was*

Gillette added that cats possessed "comedy of the very highest known altitude. Though I have not considered the matter, it seems to me that no other animal is possessed of such an exquisite and fastidious sense of humor—not even man himself."[89]

The cats, however, were not the only animals found at the castle. There were goldfish and frogs and other livestock. Once, he took George H. Broadhurst, a well-known playwright and theater producer, to meet some of the sheep he kept on the castle grounds. When the sheep came running to the bars to greet Gillette, he beamed with pride. "See how the little things love me, George!" he said. "Love-thunder!" replied Broadhurst. "They come to you because they are hungry and they think you are going to feed them."

"George," replied Gillette, "when you have reached a certain age that passes for love."[90]

Gillette spent many a day riding his mini-railroad around his property, but when he actually had to leave the castle, his favorite mode of transportation by land was his motorcycle. As on his train, speed was his constant companion on his bike. Neighbors would often see Gillette racing through the hills of Connecticut on it well into his old age.

In the early years after the castle's completion, he also continued to maintain his houseboat the *Aunt Polly*. Unlike on the train, his time on the motorcycle and *Aunt Polly* were not accident free. In 1921, he fell while on the boat, hurting his arm in such a severe manner that he was briefly hospitalized.[91] This injury paled in comparison to one obtained on his bike in 1925, when Gillette was seventy.

On the evening of August 10, he was driving about a mile away from the castle, trailing a car driven by a neighbor. When the car in front of him turned, Gillette did not slow and careened into the car. He was hurled from

his motorcycle and knocked unconscious. A nearby doctor rushed to the scene. When Gillette regained consciousness after many minutes, he was disoriented. "What happened?" he asked.

The doctor informed him there had been an accident.

"Was I in it?" the actor questioned.

"I think you are in it," answered the doctor.

Gillette laughed. He then disregarded the doctor's suggestion that he visit a nearby hospital and appears, despite the trauma, to have escaped the incident with only some cuts and bruises.[92]

A week later, Gillette was brought before a judge and was accused of recklessness. He pleaded his innocence, claiming, "To be reckless is to be thoughtless and I never thought so quickly in my life."

As the *Hartford Courant* reported, "This definition impressed the court," and Gillette was not charged with reckless driving. Apparently undeterred by the accident, Gillette continued to ride his motorcycle for several more years.

The *Aunt Polly* was not as lucky. In December 1932, the ship caught fire under mysterious circumstances. After reports that Gillette told local firefighters to let the craft burn, rumors began to circulate that Gillette had intentionally burned the boat for the insurance money. Gillette addressed these allegations in a letter to a local paper. After thanking people "throughout the United States and abroad" for writing him condolences about the demise of the craft, he said, "The report circulated by dear friends in Hadlyme to the effect that I set fire to the yacht myself in order to get the insurance on her, is a trifle incorrect, owing to the fact that there was no insurance. I did not think of it in time."[93]

At the base of the castle near the Chester-Hadlyme Ferry entrance ramp, the remains of the boat are still visible at low tide, when visitors can see about one hundred feet of what is left of the hull. In 2003, the wreck was designated an archaeological preserve by the state. With the water lapping against the aging hull of the ship in the shadow of the castle, the spot seems a fitting final resting place for the houseboat that was the precursor to the castle.

12

Ozaki Yukitaka

Amid the giant personality of Gillette, those who visit or study the castle are sure to encounter a quieter but no less intriguing character named Ozaki Yukitaka. A native of Japan, Ozaki was Gillette's longtime servant and friend. The two met relatively early in Gillette's career, with Ozaki serving as the cabin boy on Gillette's first houseboat.

Ozaki impressed the American actor with his kindness and hard work. As Guthrie, Gillette's friend, recalled in the slightly patronizing fashion she tends to use when talking about Ozaki, "William became so much attached to the small, lovable being that he made Ozaki his dresser in the theater, and for forty-odd years they were together through the experiences of William's stage career."[94]

During their more than four decades together, Ozaki worked as Gillette's butler and valet and helped oversee the construction of the castle. He lived near the water's edge on the second floor of a small cottage that is still visible today near the Chester-Hadlyme Ferry terminal. His house has never been open to the public. The first floor of the cottage housed a donkey that Ozaki would ride to and from town and to and from the castle itself. Beside the cottage, Ozaki tended to an elaborate and beautiful flower garden.

There were rumors that Gillette employed as many as two hundred Japanese servants at the castle, but there was only Ozaki and a younger Japanese man named S. Takizawa who worked as valet and servant in the house.

As he had impressed Gillette, Ozaki also made a favorable impression on those who visited the castle and on the castle's neighbors. "Every day he used the donkey for plowing the garden and riding to the Hadlyme Post Office to pick up the mail," Guthrie wrote. "Whenever Gillette invited the ladies in the area up for tea, as he sometimes did, Ozaki would personally deliver the invitations. Ozaki soon became a familiar and welcome figure on the countryside."

Guthrie further described Ozaki and his relationship with Gillette, writing:

> [Ozaki's] *ancestors were of the ancient Samurai. He had dignity and poise, and William looked on him as a friend. Every night at twelve Ozaki appeared at the door of the long living room. The knock never varied, and to William's warm "come in, Ozaki" the door swung open and Ozaki, tiny and foreign, entered for that precious half-hour of conversation with William. Many a night I have gone to sleep to the sound of voices below the gallery: the incisive tones of the ironic voice so well known to theater goers and the upper squeak of Ozaki's precise singsong in discussion of world events. Promptly when the clock showed the half-hour Ozaki would depart, and his was a courtier's exit. William was as exquisite in manner to Ozaki as Ozaki was in manner to him: courteous and sympathetic. Ozaki never trespassed; he felt no embarrassment in being the Man in the Master-and-Man contract, and he relied on William's good breeding and grace to sustain the Gentleman-and-Gentleman relation.*[95]

After Guthrie's husband, Richard Burton, died, she received a letter from Ozaki, whom she and her husband had grown close with during the time they had spent at the castle. "I called them my boys, friends Mrs. Burton," Ozaki wrote of Gillette and Richard, "because they performed with laughing the jokes of happy children."[96]

The middle son of Ozaki Yukimasa and Ozaki Sadako, Yukitaka was born in 1865 in the village of Matano in the Sagami hills about thirty-five miles west of Tokyo. It was a time when Japan had just begun opening itself up to the Western world, and Yukitaka and his family embraced this early globalization. In 1888, he and his elder brother, Yukio, traveled to the United States. Yukitaka remained in the United States and went on to work for Gillette. Yukio did not like the temperature extremes and found it difficult to sleep in the heat of New York and Washington, D.C., so he decided to return to Japan. The decision had a huge impact on Japanese history and the history of the U.S. capital.

In Japan, Yukio was elected to the Japanese Imperial Diet and served in that position for more than sixty-two years, becoming known in his home country as the "God of constitutional politics" and the "father of the Japanese Constitution." Later, in 1912, as the mayor of Tokyo, he arranged the donation of 3,020 cherry trees to Washington, D.C. The gift was made in order to enhance the growing friendship between the United States and Japan. The trees were planted along the water in West Potomac Park and have had a beautiful effect on the appearance of the nation's capital ever since. The event is also commemorated in Washington each March with the National Cherry Blossom Festival.

According to Guthrie, one morning years later, Gillette read about this gift in the paper and turned to Ozaki. "I see the great Japanese statesman has your name," Gillette said. "Ozaki, without changing expression, replied, 'excuse please, Mr. Gillette; he is my brother.'"[97]

When Yukio's daughters were to attend school near Boston, Gillette invited the family to the castle, and there is a myth that during this visit Ozaki and Gillette switched places and Ozaki pretended to be the lord of the manor. This was not true, but Guthrie recounts the reunion of Ozaki with his brother as a happy one.

Back in Japan, Yukio was critical of Japan's military buildup and a proponent of universal suffrage for men and women who was often jailed for his antiwar and pro-democracy stances. In the United States, Ozaki's last years were similarly marred by the onset of World War II and the terrible war between his native country and his adopted one.

In his will, Gillette had made clear that Ozaki could keep his house and land by the ferry until his own death. But not long after Gillette's death in 1937, the political events of the time made things difficult for Ozaki.

On the morning of December 7, 1941, the Japanese launched a devastating sneak attack against the U.S. Navy base at Pearl Harbor. Ozaki was horrified. Reportedly, he fainted when he heard the news on the radio. According to one account, "Mr. Ozaki was not an American citizen but he loved America very dearly and people around Hadlyme who knew him say it was the news of Pearl Harbor that killed him. Whether it did or not, it made Mr. Ozaki very unhappy."[98]

During the war, approximately 120,000 Japanese living in America, many of whom were American citizens, were interned in camps. Ozaki was investigated by a federal agent who visited him in his home. During an interview with the agent, Ozaki said he had lived so long in America he would feel like a stranger in his homeland. The agent cleared Ozaki and

Ozaki Yukitaka's house in August 2016. *Photo by Erik Ofgang.*

walked out of the cottage with his arm around him, which Ozaki reportedly later said made him feel "as if this country had put its arms around me."[99]

Neighbors who knew Ozaki were protective of him and tried to comfort him, but Ozaki's grief was intense. He told one friend, "I have

decided to wait until the flowers have come in the spring and gone in the fall. But I shall not be here for another winter."[100]

On April 10, 1942, he wrote to Elizabeth Ives:

> *Something painfully unpleasant is going on inside my little head day and night and all I can do is just to imagine things and dream with little or no prospect of vitalizing them into actuality. Age is a fearful exacter of tolls physically and mentally. And my memory is getting worse and worse, ideas and words fail me most inconveniently, I cannot concentrate at all, days after days roll away like matters that are no concern of mine....I feel I shall not be able to do real work in the garden this time. Spirit is willing but body is weak; I am now in my second childhood and on way further yet. Everything seems so unreal, vague and fleeting unfeelingly. Perhaps it is the shadow of something that happened last December that hangs over me. It was too terrible. I was amazed, astounded, dumbfounded, shocked and stunned beyond my power of expression. For I have been living in this country fifty odd years and feeling all the time as one of the people. "Whom the gods would destroy, they first make mad" and those Japanese war lords are far worse than mad, they are the greatest criminals of the century. And I can see nothing but the total destruction of Japan in a year or so. Time will come soon when Japan will know that their worst enemy is within, not outside.*[101]

True to the melancholy prophecy of his own demise, Ozaki died peacefully in his cottage on October 2, 1942. He was seventy-seven years old. He saw the spring of 1942 and departed the earth before the coming of winter. His home has been boarded up since his death. His beautiful garden, once the envy of the neighbors, is no more. But the memory of the humble man who served Gillette with grace and kindness is as much a part of the fabric of castle lore as the fictional Holmes or even Gillette himself. If Gillette was the director of the story of the castle, then Ozaki was the stage manager, the one who brought his director's vision to life. And like Gillette, his memory has survived long after the fall of the curtain.

13

Their Final Bows

In the preface to his final collection of Holmes short stories, completed in the late 1920s, Doyle wrote, "I FEAR that Mr. Sherlock Holmes may become like one of those popular tenors who, having outlived their time, are still tempted to make repeated farewell bows to their indulgent audiences. This must cease and he must go the way of all flesh, material or imaginary." Since Doyle had attempted to kill Holmes decades earlier, the character had appeared in dozens of new stories penned by Doyle as well as on countless stages, films and radio programs. Now, at last, Doyle believed that time could do what the Falls of Reichenbach failed to do.

In this preface, Doyle wrote candidly of the murderous intentions he once harbored toward Holmes:

> *I had fully determined...to bring Holmes to an end, as I felt that my literary energies should not be directed too much into one channel. That pale, clear-cut face and loose-limbed figure were taking up an undue share of my imagination. I did the deed, but fortunately no coroner had pronounced upon the remains, and so, after a long interval, it was not difficult for me to respond to the flattering demand and to explain my rash act away. I have never regretted it, for I have not in actual practice found that these lighter sketches have prevented me from exploring and finding my limitations in such varied branches of literature as history, poetry, historical novels, psychic research, and the drama. Had Holmes never existed I could not have done more, though*

he may perhaps have stood a little in the way of the recognition of my more serious literary work.

He continued:

One likes to think that there is some fantastic limbo for the children of Imagination, some strange, impossible place where the beaux of Fielding may still make love to the belles of Richardson, where Scott's heroes still may strut, Dickens's delightful Cockneys still raise a laugh, and Thackeray's worldlings continue to carry on their reprehensible careers. Perhaps in some humble corner of such a Valhalla, Sherlock and his Watson may for a time find a place, while some more astute sleuth with some even less astute comrade may fill the stage which they have vacated.

Doyle concluded, "And so, reader, farewell to Sherlock Holmes! I thank you for your past constancy, and can but hope that some return has been made in the shape of that distraction from the worries of life and stimulating change of thought which can only be found in the fairy kingdom of romance."[102]

In actuality, Doyle was wrong. Holmes was not going anywhere. More than one hundred years after his creation and decades after Doyle penned his "final" adventure, Sherlock Holmes continues to be a pop culture phenomenon with both TV shows and movies based on his persona sure to continue appearing. But as Doyle penned those words in the late 1920s, the curtain was soon to close on the lives of both the writer who had invented Holmes and the actor who first brought him to life on the stage.

Gillette Castle was an elaborate setting that has become synonymous with the actor who built it, but it only served as the backdrop for the final act of Gillette's life. Periodically, over the years, he would come out of retirement and leave his majestic estate to tour in various productions, including Holmes revivals. In 1916, he appeared in the silent film *Sherlock Holmes*, bringing his most famous role to the silver screen. (This film was lost for decades until a copy was recently rediscovered, but more on that in the epilogue.)

As noted previously, Gillette's portrayal of Holmes breathed new life and new enthusiasm into the character. In the early 1900s, Doyle published *The Hound of the Baskervilles*, circumventing the problem of Holmes's death by making the book a prequel, but with 1903's *The Return of Sherlock Holmes* collection of short stories, he finally, truly relented and pulled Holmes out of the rushing waters of Reichenbach Falls. When Holmes reappears to Watson in "The Adventure of the Empty House," Holmes explains that he had merely faked his death so as to throw Moriarty's henchmen off the trail. It is perhaps an overly convenient plot device, but fans didn't care; their beloved Holmes had returned.

Over the next twenty-four years, Doyle would publish dozens more Holmes short stories and another novel. Some of these stories achieved great critical acclaim, and they built on the character's literary canon. But the man who returned to London was not the same as the one who had apparently fallen into the falls. Gillette's portrayal of Holmes had changed the character in ways that even Doyle could not ignore. The curved pipe, deerstalker cap and large magnifying glass were now firmly part of the character's anatomy. Readers also could not help but visualize the hard, angular features of Gillette, who had become the public face of Holmes.

Sidney Paget had illustrated the original Holmes stories, but when the character was brought back to life in *The Return of Sherlock Holmes* collection, an American illustrator named Frederic Dorr Steele was tasked with illustrating some editions. For many of his illustrations, he used Gillette as a model. This meant many readers now literally saw Holmes as Gillette.

In addition to his appearance, dress and the props he carried, the personality of the detective had changed. The period between Holmes's supposed death in "The Final Problem" and reappearance in "The Adventure of the Empty House" is referred to as the "Great Hiatus" by Holmes aficionados. Many of these fans play what's known as the "Great Game," in which Holmes researchers treat the stories like real-life histories. Among those who play the game, there are some who say Holmes really died at the falls, and the man who returns in "The Adventure of the Empty House" is an imposter. The Holmes who emerges in the later stories is as intelligent as ever, but he seems to be a bit more human, even exhibiting genuine feelings for Watson and others at different points. He has, one might argue, become more human-like or, to put it a different way, more Gillette-like. As Washington, D.C.'s *Sunday Star* put it in 1922, "Holmes was Gillette or Gillette was Holmes, whichever way you like."[103]

In 1929, at the age of seventy-six, Gillette began a farewell tour as Holmes that lasted three years. During a performance at the New Amsterdam Theater of New York, on November 25, 1929, a large ceremony took place, and Gillette received a signature book, autographed by sixty different well-known individuals, including Doyle.

Former president Calvin Coolidge commented that the production was a "public service." The author Booth Tarkington declared, "I would rather see you play Sherlock Holmes than be a child again on Christmas morning."[104]

In 1930, Gillette played Holmes on the radio for a WEAF-NBC production broadcast from New York. As many as twenty million people could have heard the broadcast, which began at 10:00 p.m. with the announcer intoning:

> *Tonight the makers of the new G. Washington Coffee present the first of a series of dramatizations from* The Adventures of Sherlock Holmes *by Conan Doyle. It is a great honor to announce that for this first performance the part of Holmes will be played by Mr. William Gillette himself, creator of this role on the stage and Dean of the American Theater.*[105]

Because of Gillette's advanced age, producers had set up a seat for him during the production, but he stood throughout, delivering the lines with the clear, crisp, realistic diction heard in theaters across the world. Either from force of habit or to help immerse himself in the role, Gillette gestured and moved in the performance in much the same way he would have had he been on stage, where the audience could actually see him. The *New York Times* wrote, "To one unacquainted with the magical hocus-pocus of a broadcasting studio, the occasion was one to shake a puzzled head over. Gone was the Sherlock Holmes of Conan Doyle's printed page, gone the shuffling, masterful figure behind the footlights; in his place only a voice—clear, precise, vibrant, but still just a voice." The review continued, "His trappings, too, that gave him a personality and a place among men, were gone. Where were the ruminative pipe, the peaked hat, the whole improbable costume? The Sherlock Holmes of the air, attired in easy-fitting tuxedo and reading his script from a stand in front of the microphone, seemed utterly unfamiliar and remote. Yet, he is worth knowing."[106]

Gillette missed the reaction of a full-sized live audience and felt uncomfortable speaking into the relatively new contraption that was

the microphone. He was offered other radio appearances but turned most down.

After the broadcast was finished, he politely declined an invitation to spend the night in New York and rode home alone on his motorcycle to Connecticut. At seventy-seven, he had lived long enough to become a stranger in the entertainment world he had helped create.[107]

As Doyle grew older, his passion for spiritualism did not wane. Gillette, on the other hand, was not impressed. Doyle tried to convert him to the spiritualist cause (as he did with most of those he knew), but Gillette was not fond of the belief system or of religion in general. "Being a man of science and an amateur architect and engineer in this age of Nietzsche, Darwin and Marx, Gillette took seriously such agnostic explanations of an impersonal, mechanistic universe, and he warmed to those who expressed them," wrote Zecher. He also expressed skepticism about religious tenets, once playfully criticizing the beliefs of Christianity in a letter to his cousin Joseph Hooker about why he had grown tired of Christmas. "I have given up Xmas—just on account of the nausea induced by the name. Since they got through with quarreling with each other as to whether God was 1 in 3, or 5 in 7, etc. etc., and took to fighting in the public prints as to whether anybody slept with the Virgin Mary or not, it seems to me decently clear people ought to draw the line. Come on over to New Years—it's just as good and without the filth."[108]

Doyle died of a heart attack on July 7, 1930. He was seventy-one. Seven years later, on April 29, 1937, Gillette died at Hartford Hospital from a pulmonary hemorrhage. He was eighty-three. He was buried on May 1 at the Riverside Cemetery in Farmington. In a small, private ceremony attended by only a few relatives and his closest friends, he was laid to rest next to his wife, who had preceded him to the grave by more than three decades. "To the very end, William Gillette, renowned actor and playwright, remained aloof and inaccessible to the public he loved to entertain," wrote the *Hartford Courant* in a story about his funeral. "By his own wish, only his near friends and closest of kin were present at the burial service."[109]

These friends included Ozaki and the relatives included his niece and nephew through his marriage. Reverend Warren S. Archibald conducted

the service, reading from the Lord's Prayer at its conclusion. Guests laid wreaths on the grave, including one sent from Charlie Chaplin, the legendary silent film star who had worked with Gillette on the original *Sherlock Holmes* production.

Gillette had left the world a large token of remembrance in the form of his beloved castle, but in the aftermath of his death, the future of that castle was uncertain.

14

Saving the Castle

If Gillette's funeral was carried out with the strict privacy he had long cultivated off the stage, his will contains the tongue-in-cheek diction he had long been known for on the stage. He wrote:

> *That the property at Hadlyme, Conn., which has been my home for fifteen years, and upon which I have built a house and other structures, together with a narrow-gauge railway of approximately three miles in length, railway shops, and a roundhouse for the two locomotives (one electric storage batteries, the other steam), and for the several passenger cars of the road; and, throughout the place, numerous paths, ponds and bridges, &c., may become the possession of a person or persons fitted by nature to appreciate not only the extraordinary natural beauty of the situation and its surroundings, but more especially the mechanical features connected with it and established upon it during the time that I have occupied it as a home....I would consider it more than unfortunate for me—should I find myself doomed, after death, to a continued consciousness of the behavior of mankind on this planet—to discover that the stone walls and towers and fireplaces of my home—founded at every point on the solid rock of Connecticut;—that my railway line with its bridges, trestles, tunnels through solid rock, and stone culverts and underpasses, all built in every particular for permanence (so far as there is such a thing);—that my locomotives and cars, constructed on the safest and most efficient mechanical principles;—that these, and many other things of a like nature, should reveal themselves to me as in the possession of some blithering saphead who had no conception of where he is or with what surrounded.*[110]

The "blithering saphead" line has become one of the most famous and often quoted lines by modern-day Gillette enthusiasts. The actor's dark humor was not lost on contemporary observers. "When William Gillette died, and the time came when his sorrowing friends must read his last will and testament, they found that the creator of the stage role of Sherlock Holmes had left them a characteristic jest, tied up in the somber business of disposing of his Connecticut estate," the *New York Times* wrote.[111]

Indeed, it was one final nod to the audience, one last piece of masterful theater for the ages, but clever as it was, it did little from a legal standpoint to prevent a "blithering saphead" from taking over his castle. In fact, shortly after the actor's death the structure was in danger of being bulldozed for a development project.

Gillette left instructions that Ozaki be allowed to continue to live in his house and use the land around it until his death. The majority of the estate was split between Gillette's niece, Florence G. Nichols, and his wife's relative, Hall Cowan, and niece, Elizabeth Ives Gillette.

Few could afford upkeep on the lavish estate, and even fewer were interested in doing so. When Gillette's heirs put the property up for sale after his death, interest from buyers was lukewarm at best.

Inventoried at being worth $65,000, the castle was advertised by the Skinner Brothers, a Hartford real estate firm. The firm billed it as "William Gillette's Famous Castle" and spared no descriptive punch when describing it in ads:

> From its lofty position atop the Seventh Sister Hill at Hadlyme, Connecticut, this sturdy landmark of native fieldstone looks down with all the quiet dignity of [a] Rhenish Castle upon the beautiful lower Connecticut River Valley. This property with its 110 acres of heavily wooded land sloping sharply upward from the river bank places the independent seclusion of a Feudal Lord's domain within convenient motoring or yachting distance of New York City. Three miles of narrow gauge railway with stations, tunnels and miniature equipment offer an unusual means of entertaining guests.[112]

Evidently there was not much interest in a "Feudal Lord's domain," and the castle received few serious offers. In October 1938, the executors of the estate—Joseph Hooker and the First National Bank of Hartford—held an auction presided over by New York auctioneer Arthur C. Sheridan. The auction was invitation only, and Sheridan said that an invitation implied that

the recipient was not a "blithering saphead." However, when pressed on the issue by the *New York Times*, he reportedly did not answer whether he would "refuse the bid of any 'blithering saphead,'" leading the reporter to conclude, "It seems he would not."[113]

As the auction neared, rumors swirled that Edward, the Duke of Windsor, was interested in purchasing the castle. On the day of the auction, potential buyers arrived early and "swarmed into the property, toiling by and afoot up the precipitous pass which leads from the country road to the castle. They inspected the castle and marveled at its ingenious and massive construction and at the miniature railroad which was Mr. Gillette's pride."[114]

But when it came time for the actual bidding, there was less enthusiasm. It was estimated that the actor had spent millions on the estate, but there were few in the crowd willing to part with any significant funds for it. The highest bid came from a New Jersey real estate broker named Louis Schlesinger, who offered a mere $25,000. "We're not renting this place, we're selling it, Mr. Schlesinger," Sheridan replied. Schlesinger upped the bid to $35,000 and the bid was initially accepted, but hoping for a more significant offer, Gillette's heirs turned it down.

With the auction unsuccessful and no buyer coming forward, Gillette's estate began to languish. In the fall of 1943, Gillette's railroad, including its two locomotives and three miles of track, was purchased by Lake Compounce, an amusement park in Bristol, Connecticut.

Earlier that year, with limited interest from wealthy buyers, Gillette's executors generously offered the castle and its grounds to the state at the price of $30,000. It was clear the estate would make a wonderful park for the state, but Connecticut could only muster $20,000 in funds. So in the summer of 1943, a plan was launched whereby the state would pay $20,000, and $10,000 would be raised through private donations. Edgar L. Heermance, then secretary of Connecticut's Forest and Park Association, led a letter-writing campaign to raise these additional funds. "You will be interested in the plan to secure for the public the valuable estate developed on the Connecticut River by the late William Gillette," he wrote to one potential donor. "The 'Castle,' with the pictures, furniture and interesting gadgets just as the great actor left them, can be maintained as a William Gillette memorial, open to the public under proper guidance. We feel it would be a shame to have these possessions scattered, the link with Gillette broken, and the property sold to private owners for a real estate development."[115]

The famous stage and film actor Charles Coburn joined the cause with a $100 donation. He wrote, "In 1936 I was with Mr. Gillette in 'Three Wise Fools,' which proved to be the last engagement he played. I feel it is a privilege

California
August 12, 1943

Mr. Edgar L. Heermance
Secretary, Connecticut Forest and Park Association
P. O. Box 1577
829 Chapel Street
New Haven, Connecticut

Dear Mr. Heermance:

Replying to your letter of August 6th, I accept with pleasure the invitation to become one of a hundred persons to contribute $100.00 each to provide the sum of $10,000.00 required to effect the plan of securing for the public welfare the Connecticut River estate of the late William Gillette.

I enclose herewith my check for $100.00, which I understand will be held in trust pending the consummation of the purchase for the purpose of maintaining the house and its grounds as a memorial.

In 1936 I was with Mr. Gillette in "Three Wise Fools," which proved to be the last engagement he played. I feel it is a privilege and an honor to be associated with you in this tribute to a truly great actor and an American of the highest type. If I were asked for the definition of a gentleman, I would answer "Mr. Gillette."

I should be happy to be kept advised of further developments in this matter.

I note the intention to ornament the names of those who have made this memorial possible. If my name should be so honored, I would prefer its use without the middle initial.

Sincerely yours,

CHARLES COBURN

CC: sw
Encl.

NEW YORK 15 GRAMERCY PARK
NEW YORK CITY 3

CALIFORNIA 8439 SUNSET BLVD.
LOS ANGELES 46

Charles Coburn's 1943 letter sent with a check for $100 in support of efforts to save Gillette Castle. *Courtesy of Connecticut's Department of Energy and Environmental Protection.*

and an honor to be associated with you in this tribute to a truly great actor and an American of the highest type. If I were asked for the definition of a gentleman, I would answer 'Mr. Gillette.'"[116]

Helicopter pioneer Igor Sikorsky of Bridgeport, Connecticut's Sikorsky Aircraft donated twenty-five dollars to the cause, as did many other

SIKORSKY AIRCRAFT

DIVISION OF UNITED AIRCRAFT CORPORATION

BRIDGEPORT, CONNECTICUT

REFER TO
LETTER NO.

July 27, 1943

Mr. Edgar L. Heermance, Secretary
Connecticut Forest and Park Association
P.O. Box 1577
215 Church Street
New Haven, Connecticut

Dear Mr. Heermance:

In view of the many personal obligations
and numerous other causes to which I am called
to contribute, it will be impossible for me to
send the amount which you mention. However, I
will be glad to send my donation for $25.00 if
this will be acceptable. Kindly inform me at your
convenience.

Sincerely yours,

I. I. Sikorsky

IIS:CB

Igor Sikorsky's 1943 letter announcing his wish to donate twenty-five dollars in support of efforts to save Gillette Castle. *Courtesy of Connecticut's Department of Energy and Environmental Protection.*

prominent and wealthy Connecticut businessmen, but not everyone was interested. The industrialist Archer Huntington wrote to Heermance that he was "not specially interested in the proposed plan regarding Gillette Castle" and declined to donate.[117]

Fortunately, Huntington's opinion was the minority one, and the state was able to raise the $10,000 necessary to purchase the castle. After a new entrance road was completed, the castle and park was opened to the public in 1944.

From the very beginning, people realized it was a special place that would help keep alive the memory of a special person. In 1948, the *Hartford Courant* wrote, "Connecticut is rich in picturesque sites, but there can be few to rival the one Mr. Gillette picked for his home....Hung above the Connecticut [River] on one of the river's highest bluffs, it offers a view of forest, plain, and water that is worth a long journey to see."[118]

The same could be said today. None now living remember Gillette's once world-famous live performances, but thousands each year continue to be delighted and entertained by the castle that was once his home.

The Castle Today

It's August 2016, and in the library of Gillette Castle, there is what appears to be a life-size mannequin of Sherlock Holmes. The figure has the deerstalker cap and the pipe in his mouth. He has long, angular features and deep, penetrating eyes, one of which is looking through the circular magnifying glass held up to his face. As a child approaches seeking to get his picture taken beside the famous detective, the figure starts to move.

"Welcome to my home," says the "mannequin," who is really Harold Niver, a Gillette impersonator who has long frequented Gillette Castle. Standing perfectly still and pretending to be a mannequin is one of his favorite tricks and one he performs several more times this afternoon. As he "comes to life" in a rapid fashion, Harold shocks many guests into surprised laughter.

It is a gag that would do William Gillette proud. Since the 1970s, Harold and his wife, Theodora Niver, have impersonated William and his wife, Helen Gillette, respectively.

The couple doesn't so much portray Mr. and Mrs. Gillette as become them, enthusiastically bringing their characters to life in a natural way that does not even feel like acting to onlookers.

"We roll with the punches," said Harold, explaining the effectiveness of their portrayal. The Nivers are not strict about their performance. While portraying Helen Gillette, Theodora admits to audience members she died long before the castle was completed, and Harold, playing William Gillette, gets bashful about his age, admitting reluctantly that he is more than one hundred years old.

Both Theodora and Harold come out of character frequently to share tidbits about the castle and Gillette from their vast knowledge.

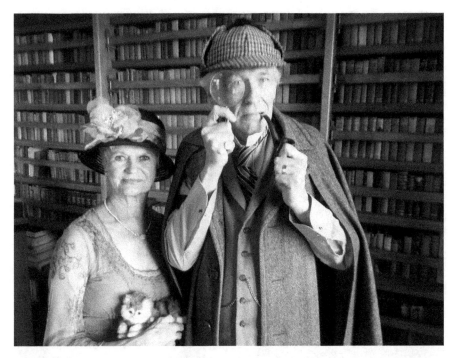

Harold and Theodora Niver portraying William and Helen Gillette. *Photo by Erik Ofgang.*

"Sherlock Holmes never used a lens like this," Harold tells one young visitor while holding up the iconic magnifying glass, adding Holmes never wore an inverness cape or a tweed cap or smoked a curved pipe until William Gillette gave him these now iconic props. Without these parts of his dress code, Harold says, Holmes is as unrecognizable as Superman would be without his cape and S-shaped emblem.

The Nivers are often present at the castle on Sundays in the summer, though they generally don't attend if the weather is not good. They are just a few of the many interesting characters attracted to the castle.

The interior of the castle is generally open from Memorial Day to Labor Day and briefly for the holiday season in December, though this schedule varies somewhat depending on the state's operating budget each year. The park itself is open year-round, and guests can always explore the castle's exterior and the property free of charge.

Visiting the castle is a great way to get up close and personal with Holmes and learn about theatrical and literary history while enjoying some spectacular architecture and some of Connecticut's most beautiful natural landscapes.

Gillette Castle tours are self-guided, but there are knowledgeable staff members in many rooms eager to explain the rooms' significance and

The staircase leading to the second level of Gillette Castle. *Photo by Corinne Ofgang.*

point out some of their eccentricities. You enter the castle into a poorly lit dungeon-like room. Near the staircase leading to the rest of the house, you'll see the secret door from which Gillette would emerge unexpectedly to theatrically welcome/startle his guests.

From there, guests are taken on a tour that brings to life one of the stage's most eccentric figures while also illuminating something of the character of Holmes.

You'll see the hand-hewn southern white oak woodwork, built-in couches, heated bed, early fire-suppression system, movable table and desk on tracks, light switches made of carved wood and those forty-seven doors, each one seemingly more intricate than the last. Guests also get to see the finely crafted cat toys available that were made in honor of Gillette's cats. You'll visit Yukitaka Ozaki's old stomping grounds and stand in the places where he and Gillette conversed.

Many longtime castle guides say they feel like they know Gillette, and it is easy to see why. Each doorway, each switch, each mirror, each hidden passage, each stone, even, seems to have been placed there for a specific purpose, and each room brims with the persona of the castle's once-and-always king.

On the grounds is a modern visitor center. The center is home to the Gillette Castle gift shop as well as the steam engine that led Gillette's train, publicity posters from his career and paraphernalia from his portrayal of Holmes, including the famous deerstalker cap and magnifying glass.

Between 1999 and 2002, the castle underwent an $11.5 million restoration project in which many repairs were made to its interior and exterior and the current visitor center was built.

Visiting the castle is worthwhile even when its interior is closed to the public. In the winter, if the ground is tinged with white snow, the castle looks even more like something out of a fairy tale. In the fall, when the leaves change color, they form a striking multicolored backdrop to the gray-white stone of the castle.

The grounds offer spectacular views of the river valley below and a variety of hiking options. You can follow along the three-mile route of what was once Gillette's railroad, crossing over the trestles and through the tunnel. Other outdoor attractions include Gillette's vegetable cellar and the outdoor railroad station, now a perfect spot for picnics.

There are two ways to visit the castle, by land or by river via the Chester-Hadlyme Ferry, which carries cars and their passengers across the Connecticut River from Chester to Gillette Castle and the village of Hadlyme. Riding the ferry either before or after your visit is part of the quintessential experience of visiting the castle. The historic ferry began service in 1769 and was used throughout the Revolutionary War to transport supplies across the river. The original ferry was pushed across the river using long poles, but a steam-powered barge replaced this in 1879.

As of 2016, the current ferry is called the *Selden III*. It was built in 1949 and is an open, self-propelled craft, sixty-five feet long and thirty feet wide.

A view of the Connecticut River from Gillette Castle. *Photo by Joe Mabel via Wikimedia Commons.*

The vessel can accommodate eight to nine cars and forty-nine passengers. You can see the ferry going back and forth from the top of the castle, and during the short ferry ride—on average it takes about five minutes—the castle looms above the river. About one hundred cars use the ferry each day, and the fee per car is five dollars.

The ferry landing is near to where the *Aunt Polly* wreck is located as well as Ozaki's house. Across the river from the castle is the town of Chester. Billed as "a place to experience old time New England," this small but vibrant village is full of stores, restaurants and classic architecture. It is worth a detour before or after visiting the castle.

If you go by land, another short detour will take you into East Haddam. This equally charming, small riverside village is home to the Goodspeed Opera House, a historic theater visible from the river, where some of Broadway's most beloved productions, including *Annie, Man of La Mancha* and *Shenandoah*, originated. Not far away is the Nathan Hale Schoolhouse, where the Revolutionary War spy and hero taught.

Though Gillette's steam engine is no longer present on the property, train enthusiasts need not despair. The area is also home to the Valley Railroad Company, which has operated the Essex Steam Train & Riverboat since 1971. The company uses vintage steam and diesel locomotives to power historic railroad cars that guests can ride. They can take this old-fashioned train to a luxurious riverboat that passes by Gillette Castle. Or guests can take the train directly to the Chester-Hadlyme Ferry and walk up to Gillette Castle from the ferry landing.

The ferry takes passengers to the base of the park, and to get to the castle, they need to hike up a hill of moderately graded trails. The total hiking distance is three-quarters of a mile round-trip, and the train ride, ferry ride and the hike generally together take about an hour each way. It makes for a somewhat intense day trip but one that is hard to

Above: View of the ferry from Gillette Castle. *Photo by Joe Mabel via Wikimedia Commons.*

Right: View of Gillette Castle from the ferry in August 2016. *Photo by Erik Ofgang*

beat. Incorporating both a train and boat ride on the way to the castle is truly in keeping with the spirit of Gillette and one of the best ways to experience his estate.

The stately architecture and quiet riverside setting of the castle and area at large can cast a spell on visitors. On a warm spring or summer's day one almost expects to see horse-drawn carriages traversing the road to the castle.

It's a spell that Gillette would later claim to have cast by accident. "Someone once mustered up the courage to ask Mr. Gillette why he built a spurious European Castle on one of Connecticut's most beautiful prospects," wrote the *Hartford Courant* in 1948.

> *A more traditional form of architecture, his questioner suggested, would fit better into a landscape familiar with neither Rhinemaidens nor dragons. Further, the questioner asked—he was a conventionalist—how did Mr. Gillette justify running the small-scale steam train that was his delight around the grounds of the imitation ruins of a medieval castle? Mr. Gillette, courteous as ever, explained: He had not intended, he said, to build a castle. He had merely laid out a house that had in it all the things he had always wanted in a house—a main room big enough for his entertainments, rooms with space enough on their walls to hang his pictures, small rooms and terraces where he could see pleasing views. He set what he wanted down on paper, and, he said, he was quite as surprised as his neighbors when the result turned out to be a castle.*[119]

What a surprise it has turned out to be.

Epilogue

William Gillette never liked curtain calls.

Not in the middle of the play anyhow. Until the early 1900s, curtain calls between acts were common. Gillette felt these shattered the illusion of reality he strove so hard to create as an actor.

"If I ever write another play it will be on the promise that no act calls are to be given while it is being played," he said during the later half of his career. "When the curtain goes down that will be the end. It will not be raised again, and if I am acting in the play I will not show myself before the curtain. Of course I could attain this result with certainty by writing a bad play, and in that case I will be worrying about other things than theories. There is no artistic excuse for curtain calls, and I trust audiences will one day take the same view."[120]

The most famous stage actor of his day, Gillette filmed only one movie, *Sherlock Holmes* in 1916. That film, like many classics of the silent era, was lost. For decades, not a single copy of it was known to exist, and the only video recording of Gillette playing Holmes was a short clip, a few minutes long, of one of his stage performances.

Then, unexpectedly in October 2014, Cinémathèque Française, a Paris-based film organization that holds one of the largest archives of film documents and film-related objects in the world, and the San Francisco Silent Film Festival announced the 1916 film had been found. Just shy of one hundred years after it was filmed, one of the holy grails of silent film had been rediscovered. Gillette's passionate fans in Connecticut and beyond

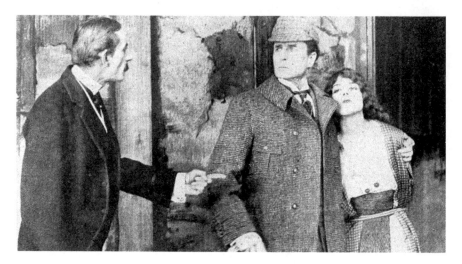

William Gillette in the 1916 silent film *Sherlock Holmes. Courtesy of Wikimedia Commons.*

could now witness the master actor in action for the first time as Holmes, the character he helped bring to life.

It is impossible to overstate the excitement the rediscovery of this film generated. The story garnered international media attention generating headlines in the *New York Times, Smithsonian Magazine* and elsewhere.

The film was wrongly catalogued by Cinémathèque Française and was discovered just weeks before the announcement of the find was made. The surviving version of the film is a duplicate negative that was sent to France after the First World War.

After the find was announced, I interviewed Robert Byrne, a film restorer and president of the board of directors of the San Francisco Silent Film Festival. Byrne said the work of restoring the ninety-eight-year-old film was painstaking. "For the restoration, all of the film rolls have been digitally scanned at 4K resolution. Then each shot and frame is being digitally repaired for stabilization and to remove warping, dirt, scratches, and other damage that has occurred over time."

The work, of course, was worthwhile, as the film revealed to modern audiences for the first time the extent of Gillette's magnetism. "When he is on screen it is almost impossible to take your eyes off him," Byrne said. "Magnetic, statuesque, precise, subtle, these are words I would use. Though Gillette came from the stage, his film acting is not 'stagey' or overly-broad in the manner that many people, mistakenly, associate with film acting of the silent era."

In an essay about the film, expert Russell Merritt wrote:

The earth moved a year ago when film curator Céline Ruivo broke the news that William Gillette's Sherlock Holmes *had been discovered in the vaults of the Cinémathèque française. The 1916 film, starring Gillette and based on his play, had long been considered the great missing link in the history of Holmes on the screen, the one opportunity to witness the archetypal Holmes, the actor who defined for generations what the detective looked like, how he moved, and what he wore. Gillette's play survives, of course, and has been given several major revivals as a Victorian period piece. But without Gillette, it has always lacked its legendary center. Now, for the first time, we can judge for ourselves the actor Vincent Starrett called the magical personality blessed with the unique talent to play Holmes.*

Merritt added:

The film is not only a powerful reminder of how Gillette the actor helped shape our image of Holmes, but also how Gillette the playwright shaped our impression of Moriarty.... The office Gillette gives Moriarty is worth particular attention. In a set piece for a new kind of Napoleon of Crime, the master rules through diabolical machines, state-of-the-art technology, and an infinitude of maps that make literal the idea that the world is at his command.... This Moriarty not only escapes Reichenbach but escapes Holmes as well. He becomes, as Holmes never does, a gateway to broader, seminal currents in international cinema. If Holmes, like the detective genre he dominates, never quite escapes the confines of the silent B-picture, Gillette's Moriarty soars, becoming the archetype of the evil genius and capturing the imaginations of directors and screenwriters worldwide. Great silent filmmakers ranging from Fritz Lang to Sergei Eisenstein pattern their criminal masterminds and their underground headquarters after Moriarty.[121]

In May 2015, the newly discovered and restored film made its U.S. premiere at the San Francisco Silent Film Festival. Mr. and Mrs. Gillette impersonators Harold and Theodora Niver traveled from Connecticut to the West Coast for the premiere. It was a sold-out crowd, but outside the theater, a line of Sherlock Holmes fans had formed, hoping in vain for tickets. The Nivers provided fans with the next best thing to seeing the film: meeting Mr. and Mrs. Gillette.

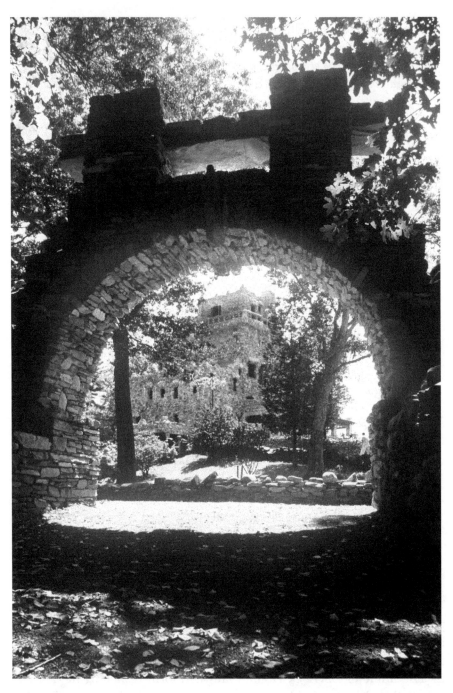

Gillette Castle visible through one of the archways on the property. *Courtesy of Connecticut's Office of Tourism.*

That September, the film made it to Connecticut, where it debuted, fittingly, at Gillette Castle. Many Sherlockians in the state flocked to see it. Finally, after ninety-nine years, two world wars and ten decades' worth of dust, it had come home for a curtain call even Gillette would have approved of.

But as dramatic as the event was, for those who had long explored the nooks, crannies and many mysteries of Gillette Castle, it did not feel like the first time they had seen Gillette perform. After all, anyone who has ever visited the castle has witnessed Gillette's flair for the dramatic. And to those among us who have spent a great deal of time there, Gillette and his alter ego feel like old friends. Standing in the Great Hall or walking on the grounds of the castle, tracking the path the railroad once trod, one does not need a film to picture the legendary actor and the even more legendary detective he helped save all those years ago from an untimely grave.

As spellbinding as the film is, the castle is his true curtain call, and for as long as it stands it will be a monument not just to Gillette but to Holmes and therefore Doyle as well. A place where in our imaginations at least, the sound of a locomotive's whistle mingles with the footfalls of a horse pulling a handsome cab, where the burning kerosene that lit early American theaters fuses with the streetlights of 1890s London. From the corner of your eyes, you'll see wisps of smoke from a curved pipe, always a curved pipe, and as the wind blows rustling over the dry leaves in the distance, if you listen closely enough, perhaps you'll hear an English accent speaking an immortal line as though for the very first time: "Elementary, my dear Watson."

Notes

Introduction

1. Doyle, *Memories and Adventures*, 99.
2. Ibid., 108.
3. Zecher, *William Gillette*, 6.

Chapter 1

4. Andrews, *Nook Farm*, 56–57.
5. Van Why, *Nook Farm*, 7.
6. Ibid., 27.
7. Duffy, "Gillette, Actor and Playwright," 53.
8. "Gillette at Last Capitulates to an Interviewer," *New York Times*, November 1, 1914, 8.
9. Gillette, "National Slavery and National Responsibility," 6.
10. Ibid., 4.
11. "Gillette at Last Capitulates to an Interviewer," 8.
12. Gillette, *Illusion of the First Time in Acting*.
13. Duffy, "Gillette, Actor and Playwright."

CHAPTER 2

14. Doyle, *Life in Letters*, 244.
15. Ibid.
16. Starrett, *Private Life of Sherlock Holmes*, 8.
17. Doyle, *Life in Letters*, 244.
18. Doyle, "Life on a Greenland Whaler."
19. Booth, *Doctor and the Detective*, 102.
20. Ibid.
21. Starrett, *Private Life of Sherlock Holmes*, 8.
22. Ibid.
23. Doyle, *Life in Letters*, 244.

CHAPTER 3

24. Fitzgerald, *Savoy Opera and the Savoyards*, 97.
25. "Gillette at Last Capitulates to an Interviewer," 8.
26. Ruggles, *Edwin Booth*, 249.
27. Thomas, *Adventures Among Immortals*, 266.
28. Zecher, *William Gillette*, 86.
29. Ibid., 103.
30. "The Professor," *Hartford Evening Post*, January 10, 1880.
31. "'The Professor' at the Arch," *Philadelphia Inquirer*, January 13, 1880, 4.
32. "Amusements," *New York Herald*, June 2, 1881, 6.
33. "Amusements," *New York Times*, June 2, 1881, 5.
34. "Theatrical," *Hartford Daily Courant*, November 28, 1881.

CHAPTER 4

35. "Held by the Enemy," *New York Times*, August 17, 1886, 5.
36. Gillette, *Illusion of the First Time in Acting*, 29.
37. Zecher, *William Gillette*, 184.
38. Doyle, *Memories and Adventures*, 99.

Chapter 5

39. Doyle, *Memories and Adventures*, 99.
40. Ibid., 99–100.
41. "A Hartford Playwright's Success," *Hartford Courant*, October 31, 1896.
42. Zecher, *William Gillette*.
43. Booth, *Doctor and the Detective*, 243.
44. Zecher, *William Gillette*, 140.
45. Doyle, *Memories and Adventures*, 99.

Chapter 6

46. Sashower, *Teller of Tales*, 214.
47. Booth, *Doctor and the Detective*, 244.
48. Zecher, *William Gillette*, 290.
49. Doyle, *Life in Letters*, 411.
50. Ibid., 419.
51. Zecher, *William Gillette*, 291.
52. "Gillette's Latest Success," *Hartford Courant*, October 27, 1899, 10.
53. "Conan Doyle's Hard Luck as a Playwright," *New York Times*, November 19, 1905, 7.
54. Doyle, *Life in Letters*, 420.
55. Sashower, *Teller of Tales*, 214.

Chapter 7

56. "Gillette's Latest Success," 10.
57. "'Sherlock Holmes': What New York Critics Say of Gillette's New Play..." *Hartford Courant*, November 8, 1899, 12.
58. Zecher, *William Gillette*, 314.
59. "Don't Want American Plays," *New York Times*, September 13, 1901, 7.
60. "Lyceum Theater," *London Times*, September 10, 1901.
61. "Gillette's Success," *Hartford Courant*, September 23, 1901, 11.
62. "Gillette's London Success," *New York Times*, November 23, 1901, 9.
63. "Prince Compliments Gillette," *Hartford Courant*, December 3, 1901, 1.

Chapter 8

64. "Gillette's Farewell: Promises to Make No More Speeches Before the Curtain," *Hartford Courant*, March 25, 1901, 8.
65. "It's an Aquatic Freak," *Brooklyn Eagle*, July 7, 1896, 8.
66. Zecher, *William Gillette*, 263.
67. "Mr. Gillette's Polly Ann," *Hartford Courant*, September 13, 1900, 8.
68. "Gillette Relates His Experiences in Old Houseboat," *Hartford Courant*, July 31, 1929, 9.

Chapter 9

69. "Interviewing Gillette's 'Castle' on Hadlyme Hill," *Hartford Courant*, January 23, 1921, 1.
70. Schickel, *D.W. Griffith*, 417.
71. "Gillette's Castle," *Washington Post*, February 2, 1936, B2.
72. Folsom, *Great American Mansions and Their Stories*, 184.
73. "Interviewing Gillette's 'Castle' on Hadlyme Hill," 1.
74. "Is Gillette Building Castle on the Connecticut River?," *Hartford Courant*, October 6, 1918, 1.
75. Woodside, "Castle Restored, Including the Quirks."
76. "Is Gillette Building Castle on the Connecticut River?," 1.

Chapter 10

77. "Interviewing Gillette's 'Castle' on Hadlyme Hill," 1.
78. Warehouse, "William Gillette Actor Dead," 1.
79. Van Name, *Gillette Castle at Hadlyme*, 13.
80. Zecher, *William Gillette*, 437.
81. Burton, *Three Parts Scotch*, 156.
82. Grimes, "Unwinding in a Winding River Valley."
83. "Interviewing Gillette's 'Castle' on Hadlyme Hill," 1.

Chapter 11

84. Gillette, "William Gillette's Railroad," filmed 1927, YouTube video, 1:44, posted July 2012, https://youtu.be/xPws_KSmToo.
85. "Gillette's One-Man Railroad Fills Actor's Boyhood Desire," *New York Times*, August 20,1930, 15.
86. "'Sherlock Holmes' Builds Miniature Railway," *Popular Mechanics*, October 1930, 636.
87. Zecher, *William Gillette*, 214.
88. Ibid., 216.
89. Ibid.
90. "You Know It!" *Warren Sheaf*, December 11, 1918.
91. "William Gillette Injured on Boat," *Hartford Courant*, January 18, 1921, 1 .
92. "William Gillette Hurt When Hurled from Motorcycle," *Hartford Courant*, August 10, 1925, 1.
93. Ryan, "Time to Fix Up the Castle."

Chapter 12

94. Burton, *Three Parts Scotch*, 162.
95. Ibid.
96. Ibid., 164.
97 Ibid., 163.
98. Wheeler, "Where Mr. Ozaki Delivered the Mail," 21.
99. Zecher, *William Gillette*, 575.
100. Ibid., 576.
101. Ibid.

Chapter 13

102. Doyle, *Sherlock Holmes: The Complete Novels and Stories*.
103. "A Man of Many Parts," *(Washington, D.C.) Sunday Star*, February 12, 1922.
104. From copies on display at the Gillette Castle Visitor Center.
105. Zecher, *William Gillette*, 534.

106. "New Sherlock Holmes Sleuth on the Radio," *New York Times*, October 26, 1930, 168.
107. Zecher, *William Gillette*, 531.
108. Ibid., 189.
109. "William Gillette Service Carries Out His Wishes," *Hartford Courant*, May 2, 1937, 10.

Chapter 14

110. "Gillette's Will Asks That Railroad Be Saved from 'Sap Head' Buyer," *New York Times*, May 5, 1937, 27.
111. "Gillette's Estate to Be Auctioned Oct. 1," *New York Times*, September 11, 1938, 62.
112. Zecher, *William Gillette*, 572.
113. "Gillette's Estate to Be Auctioned Oct. 1," 62.
114. "Halts $35,000 Sale of Gillette's Estate," *New York Times*, October 16, 1938, 29.
115. Edgar L. Heermance, letter to Faith Baldwin, July 27, 1943.
116. Charles Coburn, letter to Edgar L. Heermance, August 12, 1943.
117. Archer Huntington, letter to Edgar L. Heermance, July 10, 1945.
118. "Will Gillette's Castle," *Hartford Courant*, October 13, 1948, 12.

Chapter 15

119. Ibid.

Epilogue

120. Zecher, *William Gillette*, 311.
121. Merritt, "Sherlock Holmes."

Bibliography

Andrews, Kenneth R. *Nook Farm: Mark Twain's Hartford Circle*. Seattle: University of Washington Press, 1950.

Booth, Martin. *The Doctor and the Detective: A Biography of Sir Arthur Conan Doyle*. New York: Thomas Dunn Books, 2000.

Brooklyn Eagle. "It's an Aquatic Freak." July 7, 1896, 8.

Burton, Guthrie. *Three Parts Scotch*. Indianapolis: Bobbs-Merrill Company, 1946.

Coburn, Charles. Letter to Edgar L. Heermance, August 12, 1943.

Doyle, Arthur Conan. *The Classic Illustrated Sherlock Holmes*. Stamford, CT: Longmeadow Press, 1987.

———. *A Life in Letters*. New York: Penguin Books, 2007.

———. "Life on a Greenland Whaler." *Strand Magazine*, January 1897: 16–25.

———. *Memories and Adventures*. New York: Cambridge University Press, 1924.

———. *Sherlock Holmes: The Complete Novels and Stories*. Vols. 1 and 2. New York: Bantam Classic, 2003.

———. *Splitting the Difference*. New York: Cambridge University Press, 1924.

Duffy, Richard. "Gillette, Actor and Playwright." *Ainslee's Magazine* 1 (August 1900): 52–59.

Fitzgerald, Percy. *The Savoy Opera and the Savoyards*. London: Chatto & Windus, Piccadilly, 1894.

Folsom, Merrill. *Great American Mansions and Their Stories*. Winter Park, FL: Hastings House, 1979.

Gillette, Francis. "National Slavery and National Responsibility." Washington, D.C.: Buell & Blanchard Printers, 1855.

Gillette, William. *The Illusion of the First Time in Acting*. New York: Dramatic Museum of Columbia University, 1915.

———. "William Gillette's Railroad." Filmed 1927. YouTube video, 1:44. Posted July 2012. https://youtu.be/xPws_KSmToo.

Grimes, William. "Unwinding in a Winding River Valley." *New York Times*, October 16, 1992. http://www.nytimes.com/1992/10/16/arts/unwinding-in-a-winding-river-valley.html?pagewanted=all.

Hartford Courant. "Gillette Relates His Experiences in Old Houseboat." July 31, 1929, 9.

———. "Gillette's Farewell: Promises to Make No More Speeches Before the Curtain." March 25, 1901.

———. "Gillette's Latest Success." October 27, 1899.

———. "Gillette's Success." September 23, 1901.

———. "A Hartford Playwright's Success." October 31, 1896.

———. "Interviewing Gillette's 'Castle' on Hadlyme Hill." January 23, 1921.

———. "Is Gillette Building Castle on the Connecticut River?" October 6, 1918.

———. "Mr. Gillette's Polly Ann." September 13, 1900.

———. "Prince Compliments Gillette." December 3, 1901.

———. "'Sherlock Holmes': What New York Critics Say of Gillette's New Play..." November 8, 1899.

———. "Will Gillette's Castle." October 13, 1948.

———. "William Gillette Hurt When Hurled from Motorcycle." August 10, 1925.

———. "William Gillette Injured on Boat." January 18, 1921.

———. "William Gillette Service Carries Out His Wishes." May 2, 1937.

Hartford Daily Courant. "Theatrical." November 28, 1881.

Hartford Evening Post. "The Professor." January 10, 1880.

Heermance, Edgar L. Letter to Faith Baldwin, July 27, 1943.

Huntington, Archer. Letter to Edgar L. Heermance, July 10, 1943.

London Times. "Lyceum Theater." September 10, 1901.

Mattioli, Bill. Author interview, East Haddam, April 2014.

Merritt, Russell. "Sherlock Holmes." Silentfilm.org. silentfilm.org/archive/sherlock-holmes.

New York Herald. "Amusements." June 2, 1881.

New York Times. "Amusements." June 2, 1881.

———. "Conan Doyle's Hard Luck as a Playwright." November 19, 1905.

———. "Don't Want American Plays." September 13, 1901.

———. "Gillette at Last Capitulates to an Interviewer." November 1, 1914.

———. "Gillette's Estate to Be Auctioned Oct. 1." September 11, 1938.

———. "Gillette's London Success." November 23, 1901.

———. "Gillette's One-Man Railroad Fills Actor's Boyhood Desire." August 20, 1930, 15.

———. "Gillette's Will Asks That Railroad Be Saved from 'Sap Head' Buyer." May 5, 1937, 27.

———. "Halts $35,000 Sale of Gillette's Estate." October 16, 1938.

———. "Held by the Enemy." August 17, 1886.

———. "New Sherlock Holmes Sleuth on the Radio." October 26, 1930.

Philadelphia Inquirer. "'The Professor' at the Arch." January 13, 1880.

Ruggles, Eleanor. *Edwin Booth: Prince of Players.* New York: W.W. Norton, 1953.

Ryan, Bill. "Time to Fix Up the Castle." *New York Times*, May 24, 1998.

Sashower, Daniel. *Teller of Tales: The Life of Sir Arthur Conan Doyle.* New York: Henry Holt and Company, 2014.

Schickel, Richard. *D.W. Griffith: An American Life.* New York: Simon and Schuster, 1984.

"'Sherlock Holmes' Builds Miniature Railway." *Popular Mechanics* 54 (October 1930): 636. https://books.google.com/books?id=jOIDAAAAMBAJ&pg=PA636&dq=Popular+Mechanics+1931+curtiss&hl=en&ei=rMr8TNGjLIO9nAfl4JDGCg&sa=X&oi=book_result&ct=result&resnum=10&ved=0CEoQ6AEwCQ#v=onepage&q=Popular%20Mechanics%201931%20curtiss&f=true.

Starrett, Vincent. *The Private Life of Sherlock Holmes.* New York: Mysterious Press, 1933.

Thomas, Lowell. *Adventures Among Immortals.* New York: Dodd, Mead & Company, 1937.

Van Name, Fred. *Gillette Castle at Hadlyme.* [Hartford]: Connecticut State Park System, 1956.

Van Why, Joseph S. *Nook Farm.* Hartford, CT: Stowe-Day Foundation, 1975.

Warehouse, Moore. "William Gillette Actor Dead." *New York Sun*, April 29, 1937.

Warren Sheaf. "You Know It!" December 11, 1918.

(Washington, D.C.) Sunday Star. "A Man of Many Parts." February 12, 1922.

Washington Post. "Gillette's Castle." February 2, 1936.

Wheeler, Robert. "Where Mr. Ozaki Delivered the Mail." *Providence Sunday Journal*, August 21, 1955.

Woodside, Christine. "A Castle Restored, Including the Quirks." *New York Times*, June 2, 2002. nytimes.com/2002/06/02/nyregion/a-castle-restored-including-the-quirks.html.

Zecher, Henry. *William Gillette: America's Sherlock Holmes.* [Bloomington, IN]: Xlibris Corporation, 2011.

Index

Y

Z

About the Author

Erik Ofgang is an award-winning writer, musician and magician whose work has appeared in dozens of magazines and newspapers throughout the country, including the Associated Press, the *Hartford Courant* and *Connecticut Magazine*, where he is a senior writer. His debut book, *Buzzed: Beers, Booze, and Coffee Brews; Where to Enjoy the Best Craft Beverages in New England,* was released in 2016. He teaches writing and journalism at Western Connecticut State University's MFA Writing Program and at Mercy College. When he's not writing, he can be found playing bass with the Celtic roots band MacTalla Mor. He lives in western Connecticut with his wife, Corinne, and their Labradoodle, Iris.

Lightning Source UK Ltd.
Milton Keynes UK
UKHW022034150223
417099UK00009B/206